HOW HE DI

Newsweekinternational.com

New

November 15, 2004

EXCLUSIVE

From the
Secret
Battles
To the
Private
Emotions,
The
**Untold
Story**
Of an
Epic
Election

D IT
eek

President
George W. Bush

HEG
eal Euro issue 7 JUNE 2004 www
E 100S

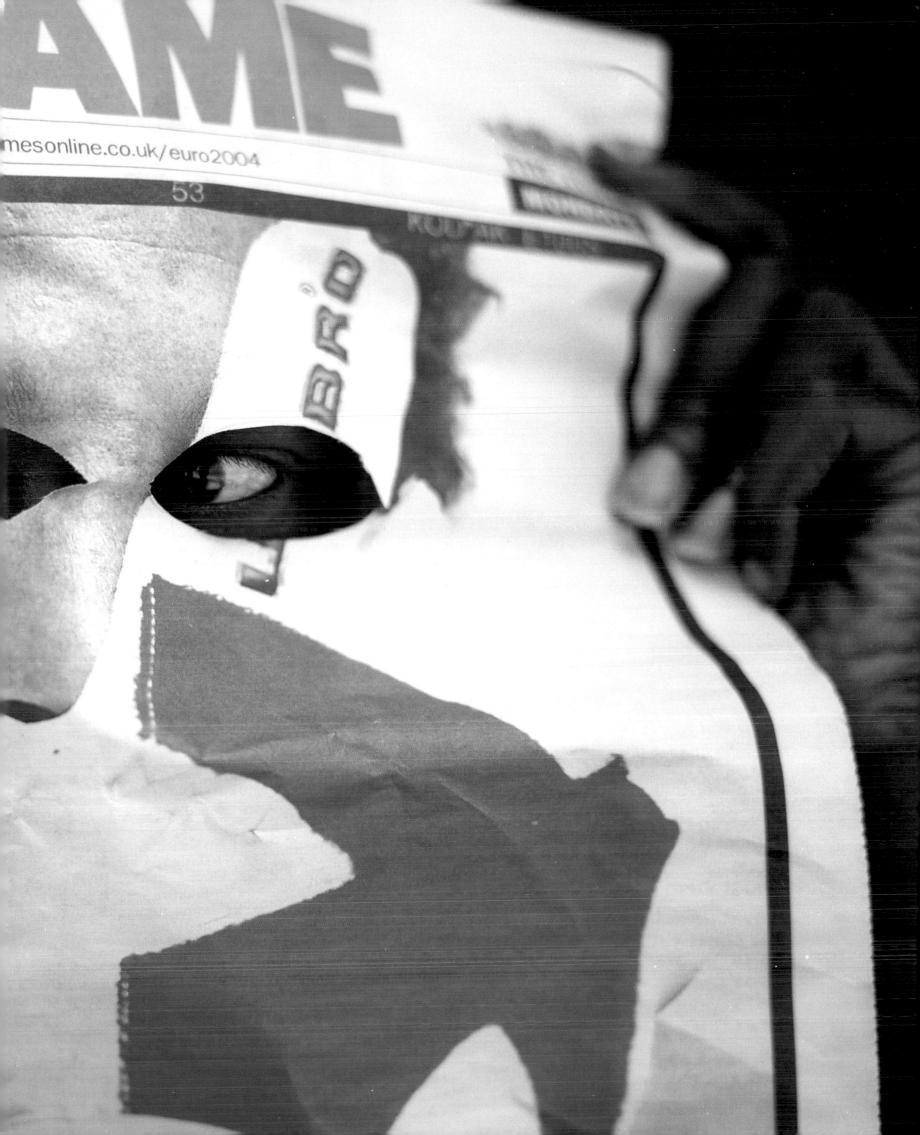

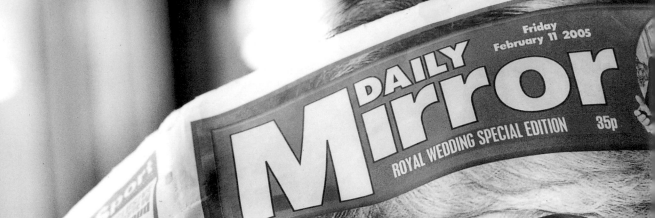

PLUS SPECIAL PULL

21ST C

**GAEL
GARCÍ
BERNA**
KICKS DOW
HOLLYWOO
DOOR
Interview by
Juliette Binoche
Photos by David
LaChapelle

G

ANA

ENTURY REVOLUTIONARIES

mber 2004

Interview

BALLSY **BJÖRK**
BY LAURIE ANDERSON
PHOTOS BY SPIKE JONZE

HOT **JAMIE FOXX**
BY ELVIS MITCHELL
PHOTOS BY
ELLEN VON UNWERTH

UNCENSORED **TERESA
HEINZ KERRY**
BY DONNA KARAN & INGRID SISCHY
PHOTOS BY BRUCE WEBER

PLUS
DAWSON
BY HAYDEN CHRISTENSEN
BILLY CORGAN BY J.T. LeROY
CHRISTIAN BALE BY GRAHAM FULLER
MINNIE DRIVER BY DEBORAH HARRY
& LISA MARIE PRESLEY'S PREDICTION!

EARTHLING

Earthling by Warren Neidich

Library of Congress number: 2005906561
ISBN: 0-9727661-7-0

Inquiries should be addressed to
Pointed Leaf Press, LLC, 1100 Madison Avenue, New York, NY 10028.

Design by SMITH
Printed by Dexter Graphics, UK.
First edition
10 9 8 7 6 5 4 3 2 1

WARRENEIDICH

EARTHLING

POINTED LEAF PRESS, LLC.

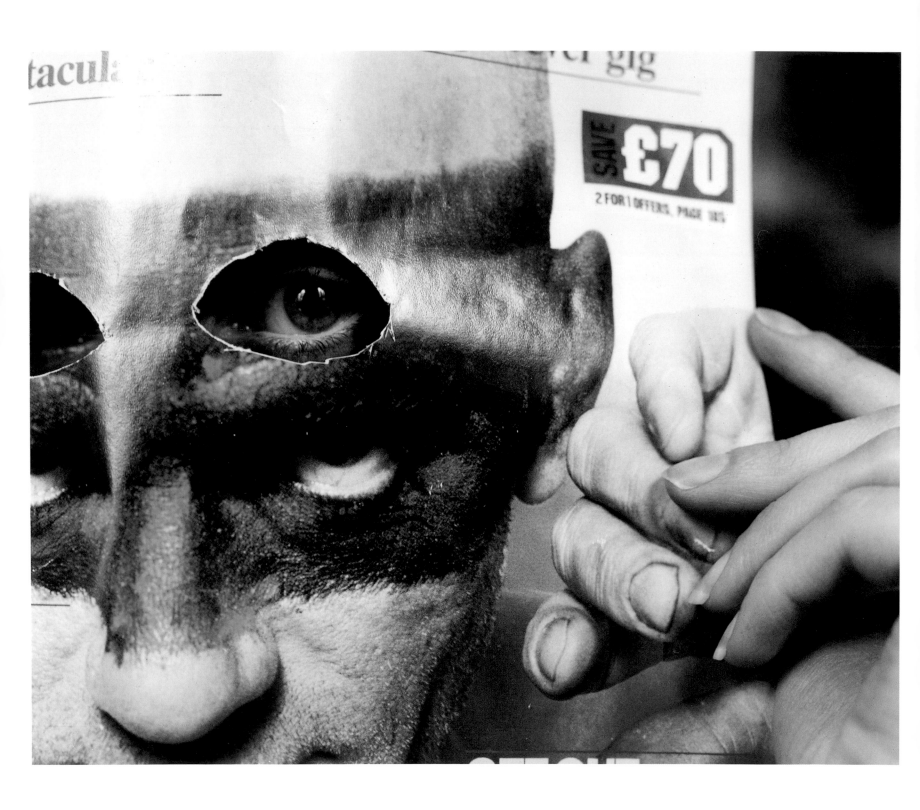

INTRODUCTION BY BARRY SCHWABSKY

Speaking of his embroideries of the map of the world in which each nation's territory is filled in with the design of its own flag, the Italian artist Alighiero e Boetti remarked "I did nothing for this work, chose nothing myself, in the sense that: the world is shaped as it is, I did not draw it; the flags are what they are, I did not design them. In short, I created absolutely nothing." A strategic removal of the artist's subjectivity would allow the work to be flooded by information about the world that, in it, can take legible form: this is the new form of realism offered by the art of the past four decades, and Warren Neidich exploits it to the full in the photographs and videos of his new *Earthling* series.

Looking at the photographs, nothing could be simpler: the focus in each one is on a newspaper or magazine with a face on its cover. It is being held wide open so as to hide the face of its reader—except that one or both eyes have been cut out of the image, revealing another eye, a living gaze, that of the "reader" who is somehow really a spy.

Everything in the photograph somehow exists to frame this gaze. But everything in the photograph somehow really is, almost, everything. The images are far more layered than one might at first notice, and the fact that there are a good many images in this series, all employing the same basic framework, helps us to see that this is the case. First of all, there is the newspaper or magazine itself—the front page or cover, and often a good bit of the back page or back cover as well. Here already is, usually, a tremendous amount of topical information, a sort of time capsule, with the cover portrait of a notable figure from the worlds of politics and entertainment, various headlines, and often on the back an advertisement, a representation of the world of commerce that is the motor for all that occupies the front, the face of the publication. This universal motor is compatible with a multiplicity of languages, design styles, topics, and political perspectives.

Beyond this flat space of the printed page, there is the always more or less visible space in which the reading that is not a reading but rather a spying takes place. Often somewhat out of focus, the setting we glimpse in these pictures is always similar but always different. It may be indoors or outdoors, dark or bright, but it is always a public place of consumption, or rather what (at the risk of sounding pedantic) might be called a public-private-public space: the kind of place where one might, in the presence of other people (in public) lose oneself in reading without being bothered (maintaining one's privacy)

so as to turn one's attention to the reported events of the day (public events). To all this, visible of course in the photographs as well as the videos, the latter add a whole further layer of information conveyed through ambient noise and conversation.

In this space, one can permit oneself to become abstracted from one's surroundings. The coffee just arrives, it is served, there is no need to get up and make it; the presence of others creates an atmosphere of conviviality in which one need not participate; the news transforms the world into a somewhat distant spectacle in which politics degenerates into entertainment and entertainment takes on its political—what Louis Althusser might have called *interpellative*—function. In a surprising way, it is the space of Cubist still-life (in which newspapers were, of course, a recurrent feature) with its multiplicity of semiotic levels among which signs are constantly being displaced, a space of quotidian paradox.

But then what is this eye, what is this gaze, that pierces the plane and meets my own in ways that may be sly, fierce, sinister, or sheepish as the case may be but which is almost always funny? What is its function? What or who is it spying on? It is tempting to answer: it's spying on me. And yet that doesn't seem quite right—it establishes complicity with the viewer too easily for the viewer to be its object as well. If anything, though the eye might be anyone's, the gaze that meets me in these pictures seems to be something like my own, only endowed with a surprising ability to violate topology and discern from behind it the surface of things. It is not the truth breaking through the spectacle but it is the desire for truth that intersects the spectacle at an impossible angle. And when I say this gaze is mine, I understand that it can never be mine alone, but forms when shared with the one that meets me in these curious images.

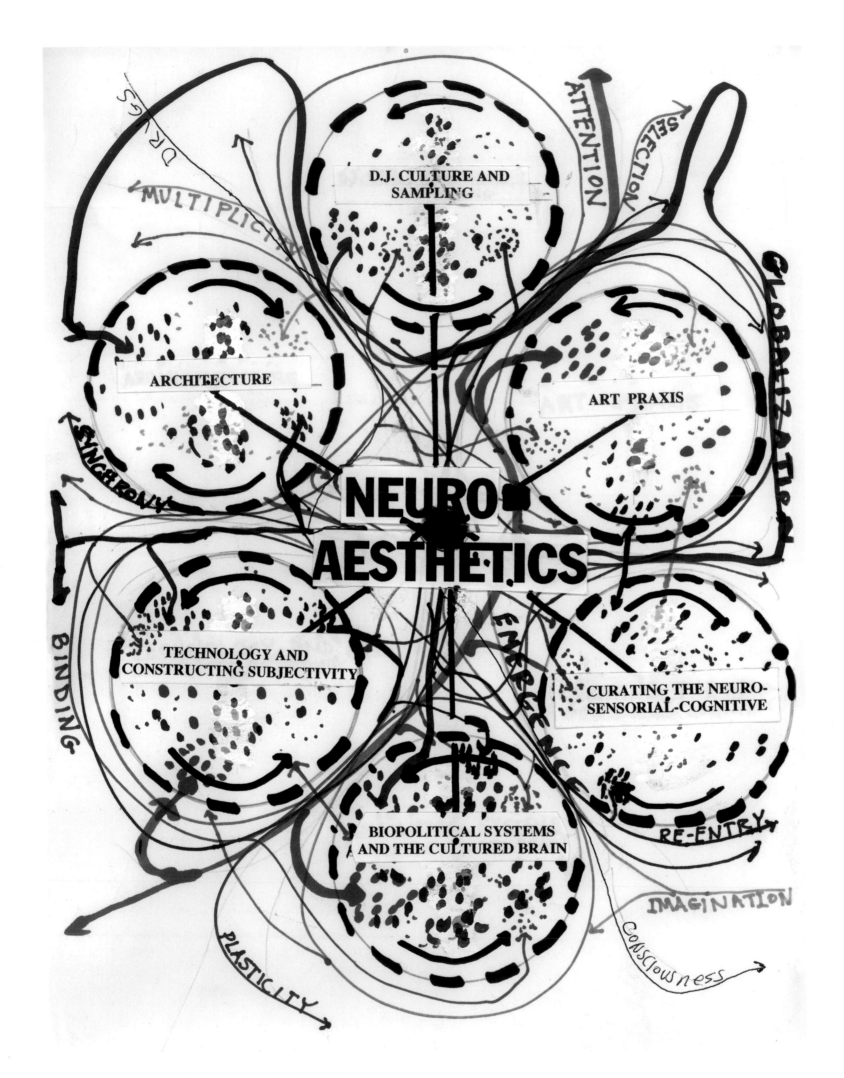

Neuroaesthetics, drawing for Delegate Folder presented at
Neuroaesthetics Conference, Goldsmiths College, May 2005.

WARREN NEIDICH
INTERVIEW BY
HANS ULRICH OBRIST

PARIS, JUNE 4, 2005

Hans Ulrich Obrist How long are you going to be here?

Warren Neidich I'm here until 4 o'clock this afternoon.

Obrist So then it's back to London?

Neidich I'm actually going to Venice.

Obrist What are you going to do there?

Neidich I am taking part in the Domus Academy. I believe you are too. Stefano Boeri and Maurizio Bortolotti invited me to be part of the Wednesday evening program with Olafur Eliasson but I will also help out in the other sessions when I can.

Obrist I'm arriving on Tuesday.

Neidich Well, I have to be there on Monday so I'm leaving today. I'm taking the train because it's cheaper. I've got some reading to do anyway.

Obrist My first question to you is about this complex new kind of work called *Earthling*, that has to do with collage and also with the cultural field. I wonder if you can tell me about this?

Neidich I have been working quite a lot with the history of apparatuses and technologies, as they intervene in photography and new media. The history of photography, cinema and new media is a history of the production and reinvention of time and space. These new forms of temporality and spatiality become imbedded in architecture, fashion, design, and aesthetic practice and as such create new kinds of network relations, for instance in the visual-cultural field. These new network relations in the real world, which might be called the real-imaginary-virtual interface, can configure neural networks in the brain. These networks are dynamic and as they reconfigure the matter of the brain they produce new possibilities for the imagination and creativity. They allow the mind to become perceptual in a very different way. This latest work deals with what I call the "Earthling" and looks at the "construction of global subjectivities" formed through the apparatus of global media.

Obrist Where does the name come from?

Neidich Sometimes it takes a year before I know what my work is really about and what it means to me. My work is originally intuitive. That being said, the name came from two sources, though this work is about a lot of other things as well. The first is science-fiction movies, where a visitor from another planet addresses those who have come to meet him or her as "Earthlings". The second is Sun Ra's cult sci-fi-blaxploitation-jazz film, *Space Is The Place,* in which Sun Ra and the Intergalactic Solar Arkestra descend on forties' Chicago from Saturn to enlighten "Earthlings" about an alternative planet built on good vibrations. I am also very much attracted to magazine culture, which is a kind of distributed information system. You can go through these magazines and DJ or VJ them; you can choose them, post-produce them, edit them.

Obrist What is your relation to them? Do you collect them or do you buy them everyday? You have something like an archive, though I'm not sure exactly what you'd call it. You deal so much with information. Do you have an archive for processing, for testing everyday information? Do you have a kind of an art lab?

Neidich I do have a kind of art lab. This project started in a very different way and then it changed midway. It began with going to cafes, as all these pictures take place in cafes.

Obrist And you were recording in cafes?

Neidich Yes, I was very interested in this idea of indeterminate spaces, spaces where people kind of linger and then move on. Tourists always go to cafes, the bohemian culture started in cafes, and I wanted to connect with that. So, anyway in the beginning of this series I started using whatever magazine I found at the cafe, as a readymade or found object. It operated as a kind of fetish of the cafe. Then as the project progressed I began to become interested in magazines in general. It was then that I started collecting them. The project started about two years ago, and about a year ago I started realizing that I was missing some of the great headlines: this one about Tony Blair in the *Morning Star*, for instance, concerns the idea of the delusional. I didn't find that one in a cafe: I saw it on a newsstand and realized that I really wanted to utilize all the information available and not restrict myself to a certain set of rules or regulations .

I think that artists have to put some regulations on the projects they do, otherwise they become unfocused. In this case I changed the rules and started collecting the magazines from anywhere and

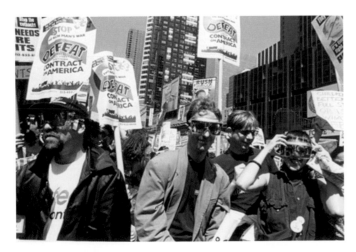

Seeing Through the eyes of Another, performance in Times Square, New York, 1996.

Goggles worn by performers in *Seeing Through the eyes of Another,* Times Square, New York, 1996.

anyplace whatever. A lot of different things started happening when I made that decision, and that is when I really got into the language of magazines. How funny they can be. How funny certain juxtapositions of headlines, titles, and advertisements can be, like Surrealist/Situationist jokes. I became interested in how headlines were used in different ways, in the multiple layers of textuality, and how they relate to different kinds of temporality. For instance, the headline is something like a sound bite: it has a very quick temporality. Then you have the subtitles, which are read in a different amount of time. You can read the newspaper in different temporal zones and you can utilize different methodologies to access the information. You can read each article through and through and in a serial way, moving from one article to another, or you can read it randomly like a dérive.

Obrist Where is your archive, because you travel all the time?

Neidich Right now it is in my studio in London. I have piles and piles of magazines—the place looks like a complete wreck.

Obrist Then if you still have studio, what is the relationship between your studio and your post-studio practice?

Neidich As with everything else there are different kinds of artists who use different kinds of strategies in producing their work. Every artist has to make work for the time they live in and they have to make work that interacts with that time. But their work also has to reflect who they are and how their own subjectivity interacts with their moment. There are some artists who use a post-studio strategy: Rirkrit Tiravanija is a perfect example. Other artists use only studio practice, like John Currin. And then there are artists like Thomas Hirschhorn, who use both. I think all these different examples represent the reality of how artists are working, although the post-studio practice is perhaps the most radical because it is more about improvisation, making works on site, nomadism, and, in some cases, immateriality.

Obrist You have said exactly what I thought, what my question was hinting at. You have a mixture. You work in the studio and you make works on the road. I am very curious to know how your studio work differs from what you do on the road.

Neidich I can give you an example of a work I make outside the studio as I am working right now at the ICA with a group of curators from the MA program at Goldsmiths for an exhibition called I.D.E.A.London. This project is a non-studio-based project even though I live in London. I am using strategies that I have learned and used when I have worked on site with other institutions. The piece is called *Librairie, Library*. Librairie is the French word for bookstore, a place you buy books. Library in the American sense is a place where you borrow books. So you have two very different economies, one based on purchase and the other on giving, sharing, potlatch.

Obrist It is happening now?

Neidich Yes, it begins next week when I get back. Nine curators, including Sofia Karamani, who I worked with directly, have asked artists to make works for the in-between spaces at the ICA, like the cafe, the hallways, etc— I chose the bookstore. I asked each of the nine curators who make up this collaborative curating team to choose the book from the bookstore that best represents, as they see it, the idea of their exhibition. These nine books will be marked and then restored to their proper places on the shelves. Informed visitors to the ICA will then be asked to take part in the exhibition by going to the bookstore and borrowing one of the books that has been marked. The methodologies normally employed by a library are being used, like the stamp that marks the time the book is being borrowed for. They are allowed to keep the book for one hour and read it in the cafe of the ICA. After one hour they are supposed to return it. The exhibition will continue until all the books disappear.

Obrist Until they are all gone?

Neidich Until they are all gone. It is about the idea of disappearance, because we are assuming that people will take the books. So this is an example of a non-studio-based practice, or as you call it a post-studio work.

Obrist And at the same time you work in London in your studio. What do you have in your studio this week in June 2005?

Neidich In my studio I have a number of things. I have drawings. I always begin with drawings. All my work is conceived first as a series of very naive drawings, maps of ideas, flows of discourses and information ecologies. I use a kind of scientific-looking drawing, with arrows and texts and things like that. They become the fundamental outline of my writings. I write in my studio. The

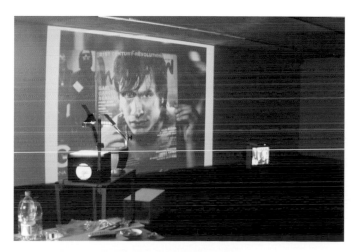

Installation and documentation, *Earthling* performance, ten-hour lecture, Contemporary Art Center, Vilnius, April 2005.

other things in my studio right now are the photographs from the *Earthling* series. There are large prints because I am testing different formats and framing styles. One thing that might interest you about these photographs is the reaction people have to them, especially how they assume they are done. As you know they are cut ups and are made only with scissors, or a razor blade. Visitors who come to my studio always ask me what program I use to make them—did I use Photoshop or some fancy technology?—because they assume that everything today is done that way. I use the most banal and naive methods. I find the magazine image and I cut out the eyes or the mouth. Also the videos are very strange when you see them. I videotape them as a photograph. It is a hybrid form. They are static images of magazine covers or newspaper front pages, still except for the occasional movement of the eyes, or sometimes in the background at the very edge of the screen there is a waiter moving or a car passing. I don't use any fancy technology at all, I just set the camera in front of the scene and document it. A document is all it is. I think it says something very interesting about how we have begun to look at visual material today as a result of our interaction with technology. We have formed special habits as a result of our experience with it. I believe this is a special case of eversion. Eversion is when things invented on the internet become part of real life, for instance, when people meeting each other in internet chat rooms become real lovers.

Obrist By that do you mean that the internet produces reality?

Neidich Yes, it is interfacing with reality and things are flowing, there is a porosity. I think things are flowing off the internet right now and off the computer screen into what I call the real-imaginary-virtual interface.

Obrist Before we move on, I would like to return to the idea of the post-studio. It has to do with the city. There was a moment in the twentieth century when there was a permanent quest for the avant-garde and basically it started in Paris, then it went to New York, then London. These were moments when everyone wanted to be in the city. Now it is more about the periphery. Everybody is moving all the time. Everybody wants to go somewhere else: the city blurs. I wonder why all my European friends want to leave Europe, while my American friends want to come to Europe?

Neidich Well, I'll begin with the first question. I think that as Stefano Boeri says the distinctions between cities, and even the cities themselves, are blurring. It is as if the city-state has given way to the urban conglomerate as a socio-economic and political entity. I think that we are also living in a moment when people are more nomadic than ever before, because of the internet, access to cheap air fares, the lingua franca of English, and global TV where people can learn about each other. Artists to a certain extent are subject to these flows as well. That is why my work is about the construction of an Earthling, of a global subjectivity. I really think we are moving, that information is moving, that economies are moving, that people are moving very very rapidly and the globe is becoming a very very small place. As a species we are evolving this way whether we like it or not. I am aware that there has been a reaction to these forms of globalization, as in the recent votes against the European Union Constitution attest. But this may simply be a problem with how the new situation is being presented. On the second question, there are many reasons why I moved from New York to London. One is that I was asked. I mean, as simple as that: they asked me to come.

Obrist Who?

Neidich The Arts Council and the AHRB invited me to do a project in London and then Janis Jefferies, who had visited my studio in New York and knew I was coming, invited me to be the visiting artist at Goldsmiths College. That's how it happened. I realized as a result of that offer that I really no longer wanted to stay in New York. First of all there is a crisis in American art right now, because so many artists are using the eighties as a kind of flashpoint for discourses about what American art is. They have misinterpreted Jeff Koons as the heir apparent of Andy Warhol and Pop Art. I believe that Warhol was a Duchampian Conceptualist who also dabbled in the cinematic aspects of Minimalism and Post-Minimalism. Warhol was not cynical about being an artist but created new forms for the understanding and production of art. The breakdown of the barriers between high and low culture, the mechanization of the act of creation, as in the Factory, and the relinquishing of material specificity were all part of his practice. Recently there are signs that this situation is changing, especially with the work of Carol Bove and Matthew Buckingham, who are finding their inspirations before the eighties. Like them I am an American artist more in the sense of Joseph Kosuth, Lawrence Weiner, Joan Jonas, Yvonne Ranier, Gordon Matta-Clark, Robert Smithson, even Donald Judd. I call them the founding artists; they wrote, they curated, they made art.

Obrist Dan Graham?

Neidich Yes of course, Dan Graham, I should have mentioned him. What happened is that as these artists were producing and distributing new kinds of information they had to create a new language in order for people to understand what they were doing. I feel I am very much part of that impulse and now-degraded utopian vision. In America the alternative spaces for artists who want to produce non-object art are either gone or have been institutionalized—what I have referred to before as the Institutionalization of the Alternative. I love the New Museum and the Drawing Center but they are now more like museums than places where artists can work out new solutions. This is of course related to funding issues. The gallery system is too strong in America. In London and Europe there is more of a balance. What I am saying is that if you make work about ideas or non-objects there are very few places to show in America. In Europe you have public-funded institutions where artists can experiment and non-object art can be produced. What is amusing is that artists like Dan Graham and Lawrence Weiner also had to start their careers in Europe, though for different reasons. Finally, there has been a reaction against discourse and theory in the United States. This has occurred for a number of reasons, some of which again have to do with the eighties. Art has to produce new sensations and new perceptions that in the end create new networks of relations, networks that allow the mind and imagination to create new possibilities that can be interpreted and written about, that make the history of thought possible. Art is a key factor in the production of thought; the history of thought and art evolve together. Art should not be recoding philosophy all the time. When Joseph Kosuth made his ground-breaking work his methodology was radical and it created new possibilities and methods for art practice. By the time those methods reached the eighties they had degenerated, becoming folded into networks of commerce they were never meant to be part of. The crash of the late eighties brought the downfall of conceptually based practice although remnants like the Institutional Critique still linger. The internet has seen a revival of its concerns but it has mutated into a socially activated practice, particularly with reference to relational aesthetics, global art, and post-productive practices. These works, by the way, have had limited effect in the United States until just recently. My work is part of this reemergence, but it is a discourse generator and Neuroaesthetics is a method for the production and distribution of information post 1993.

Obrist Who are your heroes?

Neidich Well, I already mentioned some of them, but to those I would like to add Bruce Nauman, Marcel Duchamp, Felix Gonzalez-Torres. I even have heroes from my own history—Rirkrit is in a way. We knew each other very well in the early nineties.

Obrist What is your history with Rirkrit?

Neidich We've known each other for a long time. I met him when I was a photo-based artist and I was doing my *American History Reinvented* project. We became friends and he taught me a great deal about what art could be, as well as about how to be an artist. I admire him because he changed the way people look at art. You could say that about Nan Goldin as well. I admire her work even though it is very different from my own, because she almost single-handedly changed what people thought photography was at the end of the eighties and early nineties.

Obrist You made it clear in a previous discussion we had in a London taxi that what you do is not about art and science, and obviously the whole art and science thing is a terrible cliché. But what is interests me is that you are always bridging to other disciplines: you have a great and interesting connection to science and architecture. We met through those common interests somehow. Can tell me a little bit more about how you came into this contact zone, about how it started?

Neidich Well, I have always been interested in history and critical theory. As I said earlier in our conversation I have believed from the very beginning that art should produce new sensations, new kinds of perceptions, new kinds of imaginings .

Obrist Like Felix Gonzalez-Torres's art produces extraordinary experiences?

Neidich Or hallucinatory experiences. Let's go beyond that. Art is a kind of exercise for the possibilities of the mind. It's like break-dancing or ballet.

Obrist Like a non-chemical LSD?

Neidich Yes, a non-chemical LSD. That could get me into my theory called the Society of Neurons, which is a different question and one I'm not sure I want to trip into right now. But since you asked here is a little of that theory. Different kinds of artistic experience

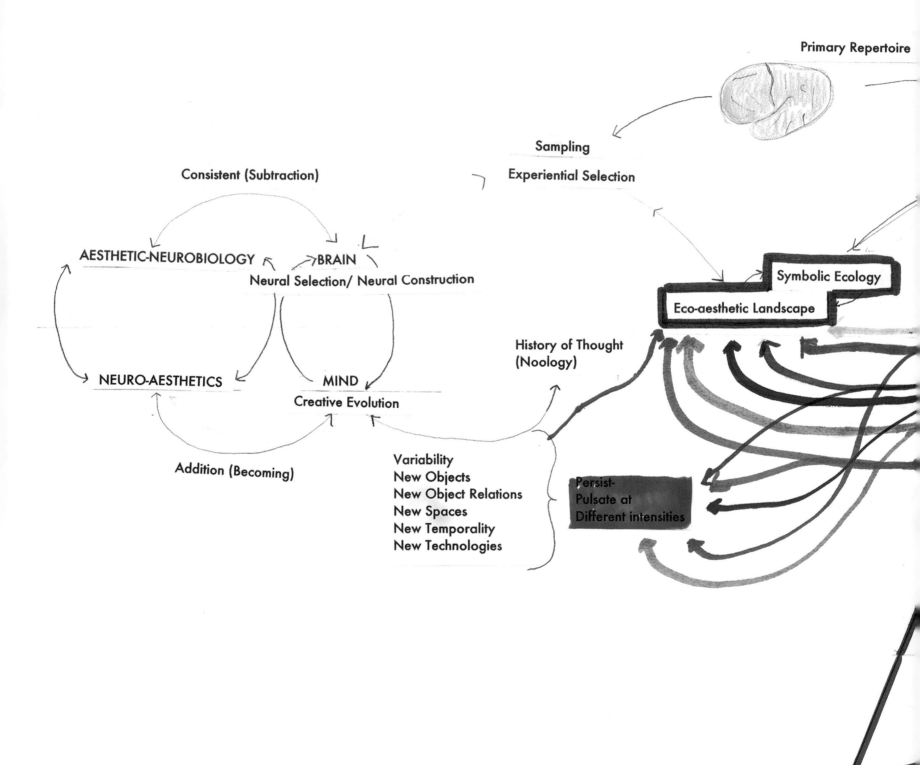

Primary Repertoire

Sampling

Experiential Selection

Consistent (Subtraction)

AESTHETIC-NEUROBIOLOGY ← → BRAIN

Neural Selection/ Neural Construction

Symbolic Ecology

Eco-aesthetic Landscape

History of Thought
(Noology)

NEURO-AESTHETICS ← → MIND

Creative Evolution

Addition (Becoming)

Variability
New Objects
New Object Relations
New Spaces
New Temporality
New Technologies

Persist-
Pulsate at
Different intensities

Ide

EARTHLING

Genetic
Developemental

Cultural Attention

Projective

Objective

Secondary Repertoire

Optical

Tech-
Nology

(intensive)

CULTURE 2

Design

TRANS-
FORM

ART

CULTURE 1

(extensive)

Architecture

Fashion

Psychological

Political

Spiritual

Economic

Historical

Sociological

Technoscapes

Mediascapes

Financescapes

Ethnoscapes

stimulate different populations of neurons which produce signals utilizing different neurochemistries, like dopamine, acetylcholine, etc. That consciousness is the product of a Society of Neurons and how they all act in harmony at any moment of awareness. They express themselves differentially depending on context in a ratiomatic manner. The ontogeny of the nervous system and the subject may be a result of a coevolutionary process by which certain kinds of cultural context call out to the developing nervous system differentially and favor the selection of certain neurochemical systems over others. Art affects visual, auditory, and haptic culture. Art, like cinema, according Deleuze, may create new forms of connectivity affecting the distribution of neurochemical systems in the brain.

My ideas about art and the brain are not intended to illustrate concepts and ideas of neuroscience, which can be a problem for art-science initiatives. They are about importing a new vocabulary that artists can fold into their art practice, as a way of energizing it through the production of difference and hybridity. If anything, my work is not about perception or sensation but rather about evolution and ontogeny. Artists like Seurat, Duchamp, Cézanne, the Futurists, Richard Hamilton, Bridget Riley, Gary Hill, and Dan Graham were all interested in science. Olafur Eliasson, Matthew Ritchie, and Carsten Holler are artists today who also share this interest. I once talked to Dan Graham about the early seventies and he told me that all the artists were reading electronics and science magazines. What I am trying to say is that many artists have folded concerns with science almost imperceptibly into larger networks of culture, sociology, psychology, economics, and history to produce a Gesamtkunstwerk.

Obrist Marina Abramovich's interest in Tessler and so on…

Neidich Yes absolutely. Artists have always worked this way. It's also interesting what happened post 1992/1993, after the internet explosion. What happened was that all the barriers, all the specificity of materials, started breaking down. Whether you are talking about art or you are talking about the barriers between different knowledge fields like science, cultural theory, or critical theory, they all started breaking down.

Obrist Has the internet changed the way you work?

Neidich I already had a history of being a scientist, having studied neurosciences and been a doctor in the eighties. After completing a project called *Camp O.J.*, where I photographed the press at the O.J.

Simpson trial as one would a rock-and-roll concert for *Spin Magazine,* I felt that I had nothing more to say about the relation of the production and mediation of the real using the theoretical tools that make up the toolbox of art. I realized that it was time to embrace my past as a scientist in order to inject a new vocabulary into my work, as well as perhaps to discover the neurobiological roots of what I was observing in the macrocultural field. Perhaps I felt the need to reinvent myself as well. Perhaps political and social systems were operating at the level of the neuron network, and biopolitical thought, as in the Society of Control outlined by Foucault, was being directed towards the brain. The *Earthling* series and a recent text I wrote for a forthcoming book called *The Body and Architecture: Constructing Global Subjectivities* are to some extent the culmination of this project. I made a decision to change my art in 1995, when I was lecturing at the School of Visual Arts in New York City. It was at this time that I started do this thing called Neurooesthetics. That practice has driven a number of other activities as well. I curated a show called Conceptual Art as a Neurobiological Praxis in 1999.

Obrist Where was this?

Neidich It was at the Thread Waxing Space and it showed twenty-five artists, including Douglas Gordon, Liam Gillick, Matthew Ritchie, Uta Barth, Carl Fudge, Thomas Ruff, and Charlene Von Heyl. It was an early exhibition for me in terms of the kind of the ways that I see Neuroaesthetics operating. I mean that I would do a very different exhibition today. The exhibition was divided into in three parts according to the functional and dynamic ways the brain works: Retino-Cortical Axis, Word-Image Dialectic, and Global Chaosmosis. The last part may not seem that obvious but it came from the idea of global networks on one hand and Deleuze's notion of Chaosmosis on the other. I was proposing that art—through its interest in dérive, hallucinogenic seeing, and distorted spaces—by creating what is referred to as intensive culture was creating a nervous system constructed not hierarchically but chaosmotically. Neuroscientists' assumptions about how the brain works used to come from looking at microscopic slides of it rather than from considering its performative and dynamic conditions. They were making certain judgments based on the tools they had. They were talking about down-up processing from the concrete to the abstract, or vice versa. They were looking at this as a model of how the brain is developed as layers. Yes, there are layers but because they didn't have the tools to measure the dynamics of the system

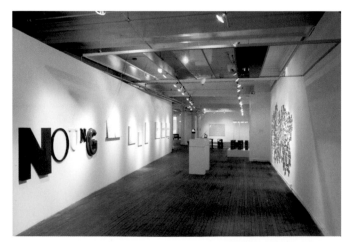

Conceptual Art as a Neurobiological Praxis, Thread Waxing Space, 1999, back gallery, showing work by Jack Pierson, Liam Gillick, Andrea Robbins.

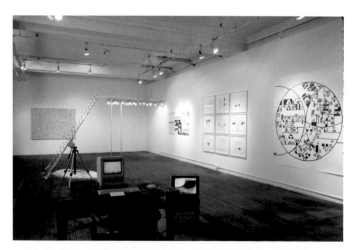

Conceptual Art as a Neurobiological Praxis, front gallery, showing work by Spencer Finch, Carl Fudge, Liam Gillick, Anne Lislegard, T. Kelly Mason.

they didn't want to develop theories in which dynamic conditions play a part. By the way, they have now begun to consider these possibilities, looking at how the dynamic systems of the brain create a metadiscourse for how networks can imagine based on rhizomatic and not arboreal architectonics—just for a moment close your eyes and imagine the Guggenheim Bilbao compared to the Louvre. This is where architecture is so relevant to this discussion, since it is architecture that has been most affected by this movement from extensive space and time, which is Euclidean, to intensive time and space, which is Riemian, folded, and multiplicitous. This has implications for how the brain is sculpted. Two years ago I did an exhibition at the Storefront for Art and Architecture where I specifically considered these issues in a group of works called *Remapping*. Most importantly, I want to emphasize that these ideas were formulated through working within an art lab and not a science laboratory.

Obrist Have you ever thought about memory in your work, because memory has always been considered static, whereas in actuality it is a dynamic process?

Neidich I have done a number of projects concerning different aspects of memory. Artists have always embraced memory and one could say there was an aesthetic memory. For instance Christian Boltanski and Annette Messanger have explored cultural memory and traumatic memory for some time now. *American History Reinvented* (1986-1991), *Collective Memory—Collective Amnesia* (1990-1994) and *Beyond the Vanishing Point: Media and Myth in America* (1996-2001) were three projects I did in which memory was a preponderant interest. The *Earthling* project riffs off these and concerns the construction of a global memory in the sense of what Paul Virilio called "phaticity". The word phatic is the root of the word emphatic. The history of the image, coevolving with that of the imagination, is one in which images are being produced that are more and more attention-grabbing, more phatic. These images are in competition with each other in the visual-cultural field, and over time they are becoming more refined, or what I call cognitively ergonomic—the images that are most successful in drawing the attention of the observer are the ones that take advantage of the dynamic ontogenic proclivities of the nervous system. What I mean is that the static condition of photography has been superseded by the linear dynamic time of cinema, which has been remediated by the non-linear digital time and space of new media (non-narrative cinema is a transitional phase). The addition of dynamic aspects has made images more and more phatic, more cognitively ergonomic. This refinement is the product of the image-industry, of collusion between advertising, cinematic special-effects, and now the political propaganda machine.

Neural Darwinism and Neuroconstructivism are two recent theories concerning the development of the brain. When combined, they form a powerful tool to understand how these images might impact the matter of the brain, and as a consequence the possibilities for thought and the construction of the symbolic subject. Basically, the brain you are born with has a population of neurosynaptic elements that compete with each other for the space of the brain and for sensations that the environment affords them. Those neurosynaptic elements that are most intensely and repeatedly stimulated gain a selective advantage over the others. Stimuli are complex phenomena that simultaneously affect multiple places in the brain: they are both global when they affect the whole brain, and local when they affect only special areas of the brain. Those neuro-synaptic elements that are less stimulated die off or wander off to make new connections. As a result the brain is sculpted by experience, both statically and dynamically. As that experience is culturally derived, culture plays a role in how the initial phase of this pruning occurs. Later on a proliferative constructive phase takes place, when those sculpted populations multiply as a result of continued stimulation by metadiscourses in the environment that produce new connectivities and becomings. This has implications for memory, especially in the global economy, because (as I said before) the history of the image is one in which images are imbedded in an evolutionary process of becoming ever more phatic. The marketplace is where these kinds of competitive forces are the most focused—think for a moment of branding and branding relations. The global economy, with its huge financial resources, is producing more and more intense stimulations and distributing them worldwide and repetitively. Especially affected are the populations of urban areas, where mediated images create their own symbolic ecology, leading to what Foucault has described as Societies of Control. As such, these images are the ones that sculpt the brain. Therefore our memories and the networks that are charged by them are largely the result of this phatic sculpting. In a way, this is a condition of the cyborization of memory.

Obrist How about the memory-mapping in your drawings? The act of memory is a dynamic process in the brain. Can you relate that to your drawings?

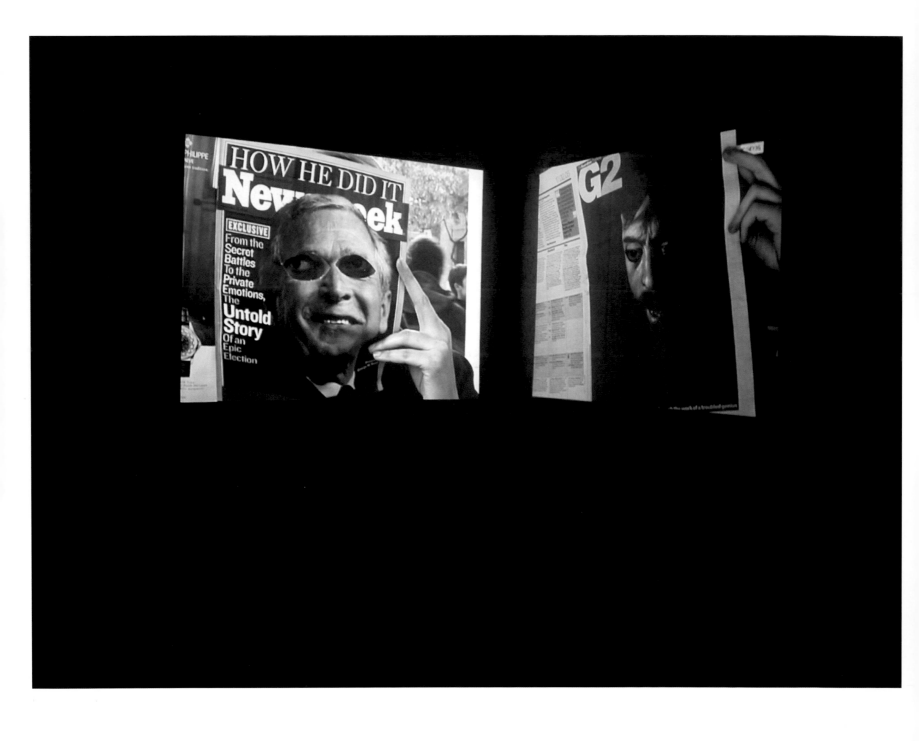

90 degrees from each other, video installation, Bregenz
Kunstverein, 2005.

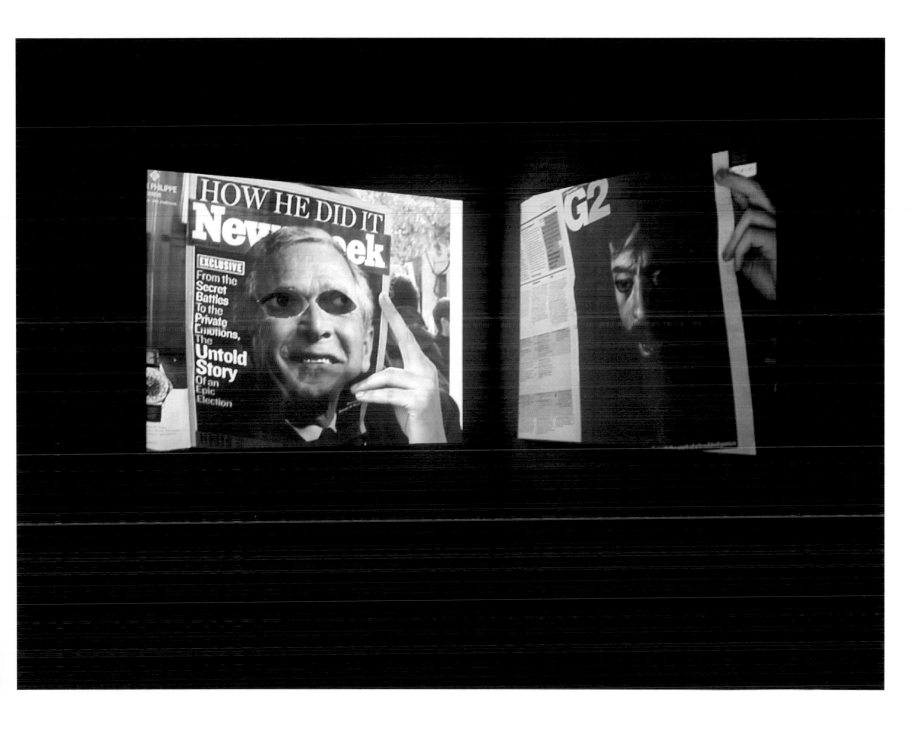

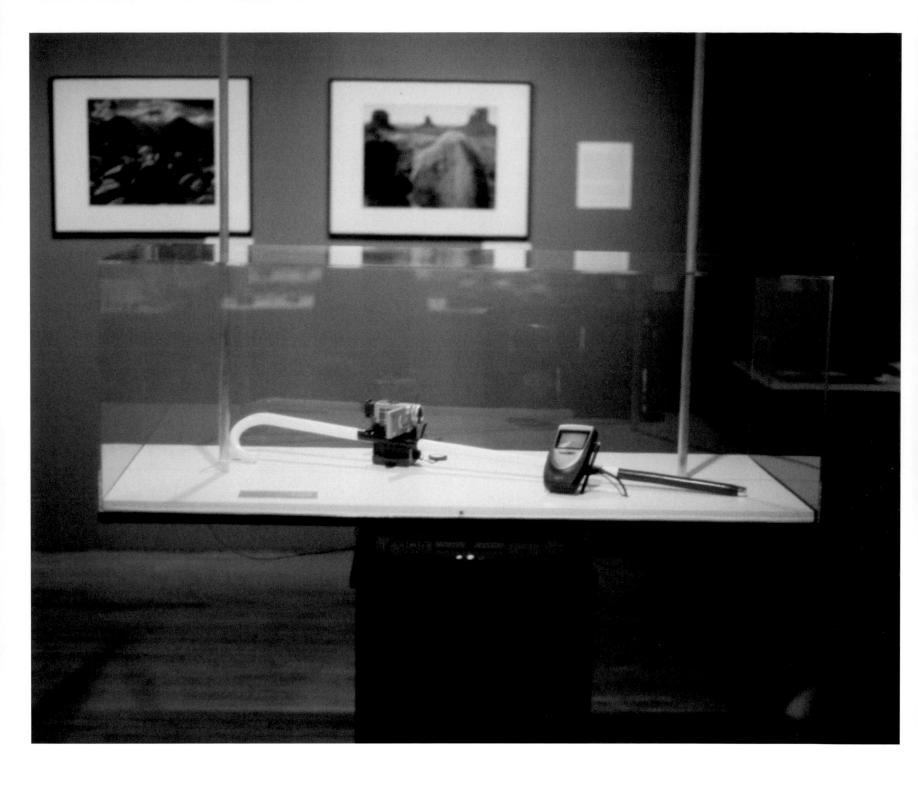

Mutated Observer Part 1, California Museum of Photography, 2002.
Mixed media with plexiglass vitrine, video camera and blind man's cane.

Neidich The drawings are more like maps. They really illustrate the condition of the flow of information as it moves through the system and between the systems that operate together to create this open autopoetic system of relations. I have drawings that are about the Cultured Brain, Symbolic Ecologies, Neuroaesthetics, and even a drawing that I did for the Conceptual Art as a Neurobiological Practice exhibition.

Obrist How about the book by Frances Yates called *The Art of Memory*? Do you find what she says interesting?

Neidich It was an essential book for artists during the early seventies, when I believe it was first published. One of the things in it that really affected me was the idea of the Law of Loci, because it shows how architecture functions as a tool for memory, or how the imagination of memory can be instantiated in the memory of architecture. It's about architecture as a means of constructing internal representations, architecture as imagination. Yates wrote about how Cicero described a method for orators to memorize their speeches by using a mental construction of a house. You close your eyes and remember a house, and in this house there are rooms, and each room represents a section of your speech. As you walk through the room there are objects that refer to specific ideas in specific paragraphs, and so on. Simply by taking an imaginary walk through the house you can remember your speech.

Obrist Can you tell me about your as yet unrealized projects?

Neidich Well…

Obrist The projects that are too big to be realized, or too small.

Neidich Right now I would like to find a place where I could set up my own institute. Something like a Bauhaus, where I could bring together the right thinkers to address issues concerning art-making in the context of today's world situation.

I am also working on this project called the *Neuroaesthetic Reading Room,* which is a totally foldable parasitic piece of architecture that I have been designing with one of my past students. It is a room made of cardboard and paper that folds up into a big sheet, in which form it travels. When it arrives at a space it is unfolded to become a platform for discussions and a projection surface as well. I am also thinking a lot about performative works. I want to do performances like the one I

recently did at the Contemporary Art Center in Vilnius, where I gave a ten-hour lecture about my theories and incorporated my videos and drawings into it. I also invite people to speak with me who inform what I am doing there. I am more interested in this than in making real physical objects.

(At this point in the interview we needed to move locations. After a break we resume.)

Obrist Can you tell me more about this memory house?

Neidich Well as I was saying, before we got disrupted, Virilio has talked about how these attention-grabbing, phatic images are being produced by advertising firms or by special-effects houses in Hollywood and they are being utilized by political parties during election campaigns. Could the apathy of the American public toward the world situation be a result of these new powerful fields of phatic signifiers, which are controlling the imaginary through their direct effect on the sculpting of neural networks—something that Arjun Appadurai has warned us about. Recently there was this amazing article in the *New York Times* about how neuroscientists are using CAT scans to see which part of the brain light up when people are looking at different political candidates. They are trying to find ways of determining which candidates are most effective in lighting up the areas of the brain where pleasure and feeling are perceived. So what was once science-fiction is now becoming reality.

Obrist I wanted to get back to your work again. In your work you use photography, video, sculpture, installation, and drawing, even the reinvention of photography. If you look at the work of Ed Rusha you could say that the car is his medium. What is your medium?

Neidich What is my medium? Well, I started as a photographer. By the way, Rirkrit Tiravanija started as a photographer too, I don't know if you know that.

Obrist He wanted to become a documentary photographer like a Magnum photographer.

Neidich Well, in answer to your question, if Rusha's medium is his car mine might be the brain. I mean that as a joke. Anyway, what is very important to understand about my work is that since I began as a photographer I tend to think of all mediums in terms of photography. For instance in London I did this project called

360 degrees, video still, 2000.

Blindsight, in which I used the machine they paint streets with to paint a green line from the subway station to Moorfields Eye Hospital, so that partially sighted people could find their way there. It was a kind of Situationist project about nested perceptual realities within the larger framework of the urbanscape. In the end, however, that line became something that I photographed and that generated images. Beyond the photographs of the document of my performance I actually made images that recounted the very nature of what it is to be blind and described the limits of the camera as image machine. Could the camera act like touch and construct a total image from a multiplicity of possible focal points in time, in memory?

I did another work called *Silent in Madrid*. My partner Elena Bajo and I brought something that's usually installed in suburban communities—a highway sound barrier—into the center of Madrid. It was a 70m sculpture that created a space of solitude and meditation in the middle of the city. For me it ended up as something to photograph. It was reminiscent of a large earth work like the *Spiral Jetty,* which became known more a series of documentary images. I mention this because I am still very much a photographer. No matter what I do, it always comes down to the static image of the photograph or the video. The difference between myself and Nan Goldin, and what makes me very close to somebody like Thomas Ruff, it is that I am not so much interested in the image. I am not a photographer who explores the image and tries to constructs a specific style: I am more interested in artists who use different mediums within photography itself. I used many kinds of historical processes in *American History Reinvented,* from platinum to albumen prints. In the *O.J.Simpson* and *Beyond the Vanishing Point* projects I cross-processed the photographs. I am much more about mediums than actual images, although I do think there is always a perfect process for a particular group of images. I am also about apparatus. Like Jean-Luc Godard, I use different apparatuses. I am interested in how an image is produced. I am making the production of the image transparent. I am not interested in dislocating the viewer from how the image was made, but want him or her to feel part of the process. In Godard's *Mépris,* for instance, the first scene opens with a man holding the microphone for the actress and the next scene is simply the camera lens. In the middle of the film Godard stops the action and interviews himself.

Obrist It's very much like Lars Von Trier, but in an interesting way he creates a different situation.

Neidich Lars Van Trier is very much like Godard in that he dispenses with all the high-tech paraphernalia of cinematic production, leaving you with the grain of the film, poor lighting, and camera movement. So by complete denial you affirm what it is you want to relinquish. As I said, everything is Godard.

Obrist Everything is Godard.

Neidich Yes, everything is Godard. If you look at what many artists are doing today, so much is influenced by him.

Obrist I think that is a great conclusion. Thank you.

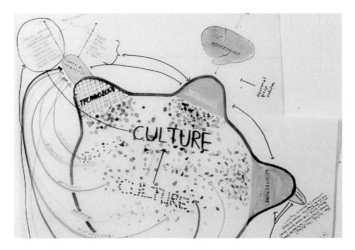

Mutated Observer Part 2, detail of Cultured Brain drawings, California Museum of Photography, 2002.

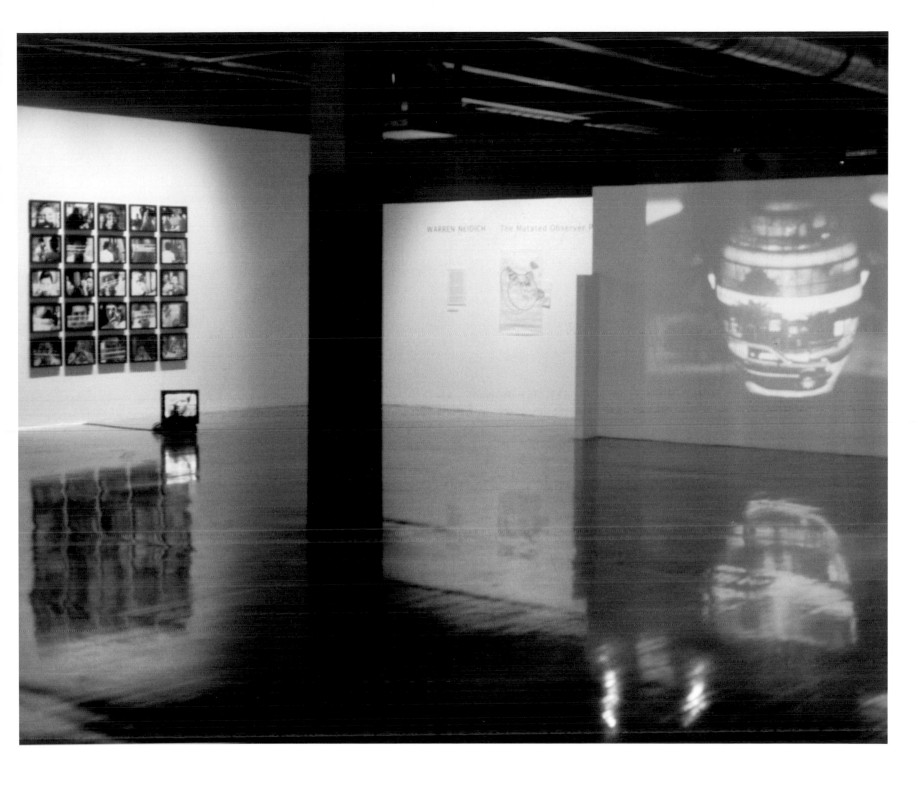

WARREN NEIDICH The Mutated Observer P

Mutated Observer Part 2, California Museum of Photography, 2002.

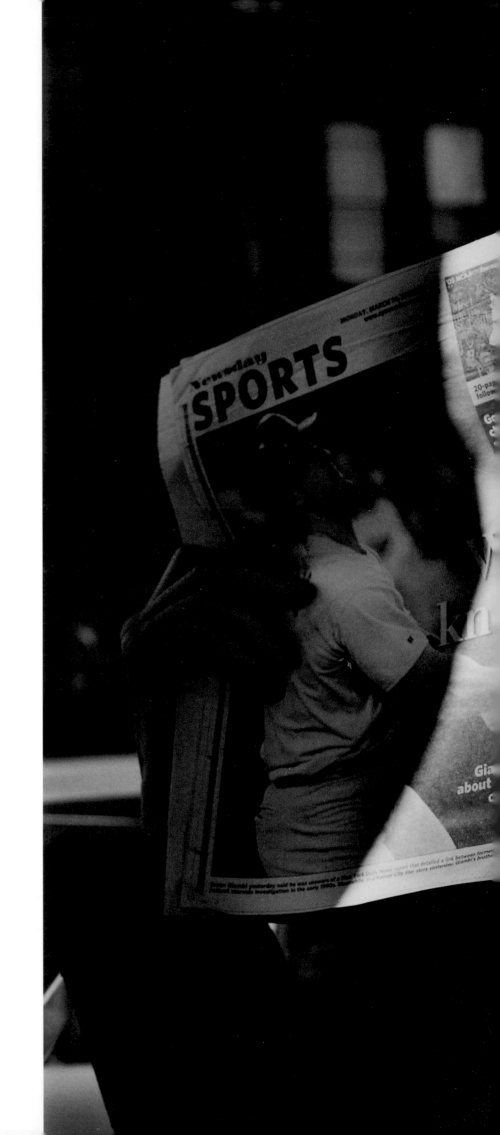

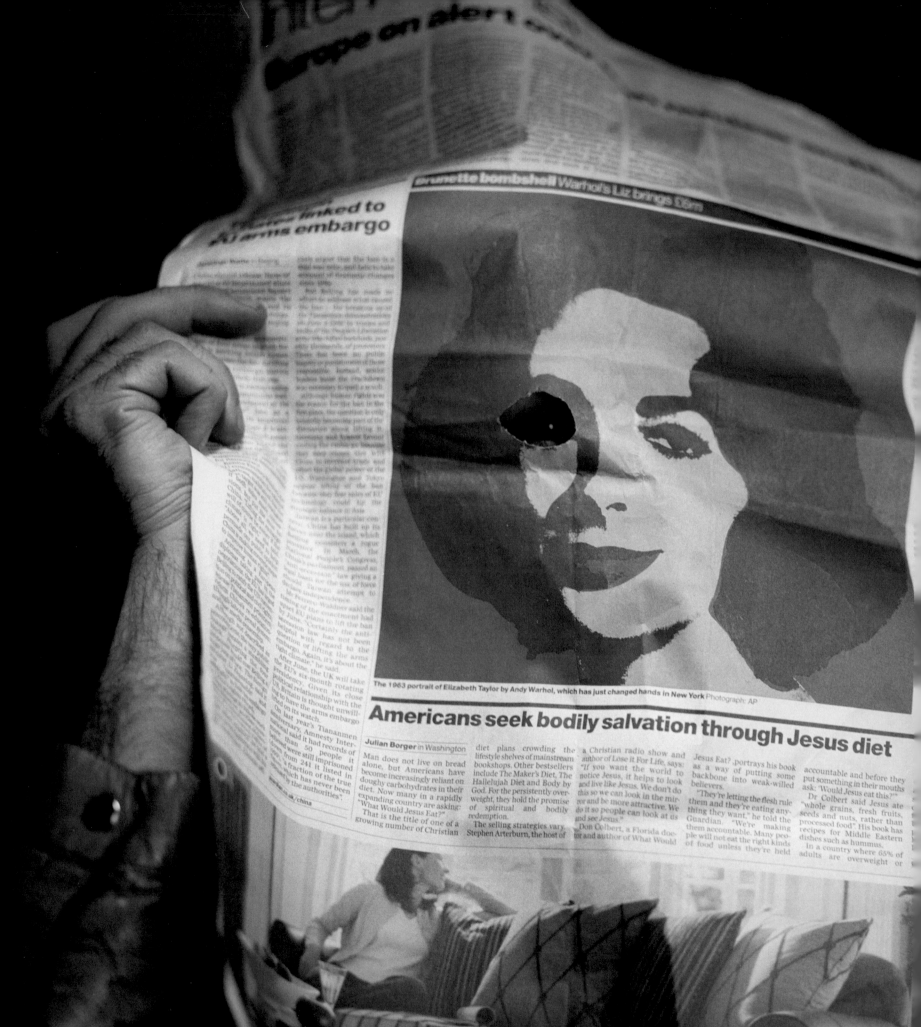

linked to
EU arms embargo

The 1963 portrait of Elizabeth Taylor by Andy Warhol, which has just changed hands in New York Photograph: AP

Americans seek bodily salvation through Jesus diet

Julian Borger in Washington

Man does not live on bread alone, but Americans have become increasingly reliant on doughy carbohydrates in their diet. Now many in a rapidly expanding country are asking: "What Would Jesus Eat?"

That is the title of one of a growing number of Christian diet plans crowding the lifestyle shelves of mainstream bookshops. Other bestsellers include The Maker's Diet, The Hallelujah Diet and Body by God. For the persistently overweight, they hold the promise of spiritual and bodily redemption.

The selling strategies vary. Stephen Arterburn, the host of a Christian radio show and author of Lose It For Life, says: "If you want the world to notice Jesus, it helps to look and live like Jesus. We don't do this so we can look in the mirror and be more attractive. We do it so people can look at us and see Jesus."

Don Colbert, a Florida doctor and author of What Would Jesus Eat? portrays his book as a way of putting some backbone into weak-willed believers.

"They're letting the flesh rule them and they're eating anything they want," he told the Guardian. "We're making them accountable. Many people will not eat the right kinds of food unless they're held accountable and before they put something in their mouths ask: 'Would Jesus eat this?'"

Dr Colbert said Jesus ate "whole grains, fresh fruits, seeds and nuts, rather than processed food". His book has recipes for Middle Eastern dishes such as hummus.

In a country where 65% of adults are overweight or

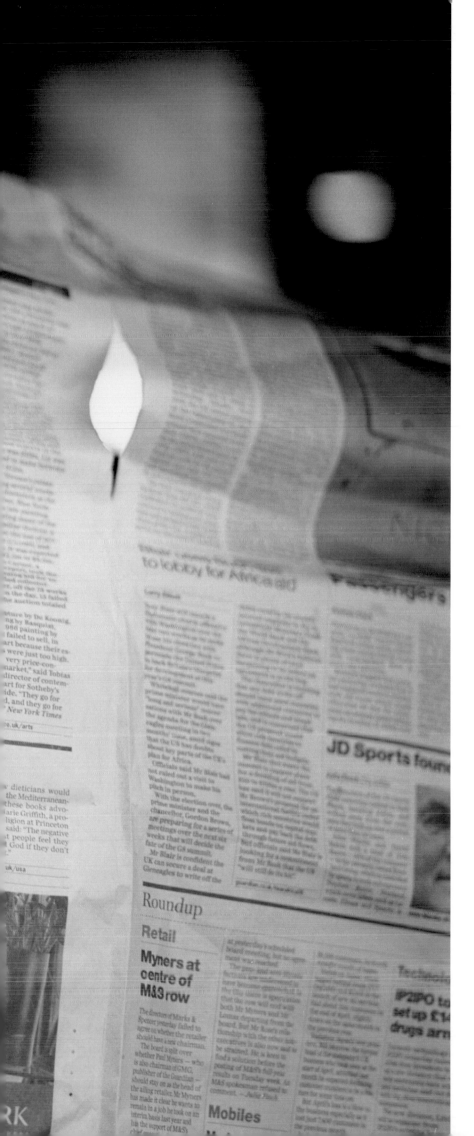

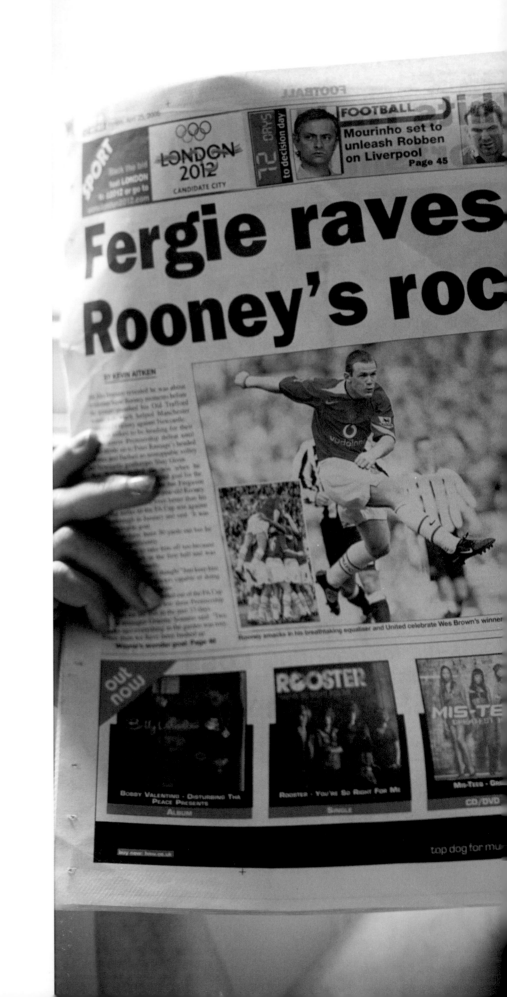

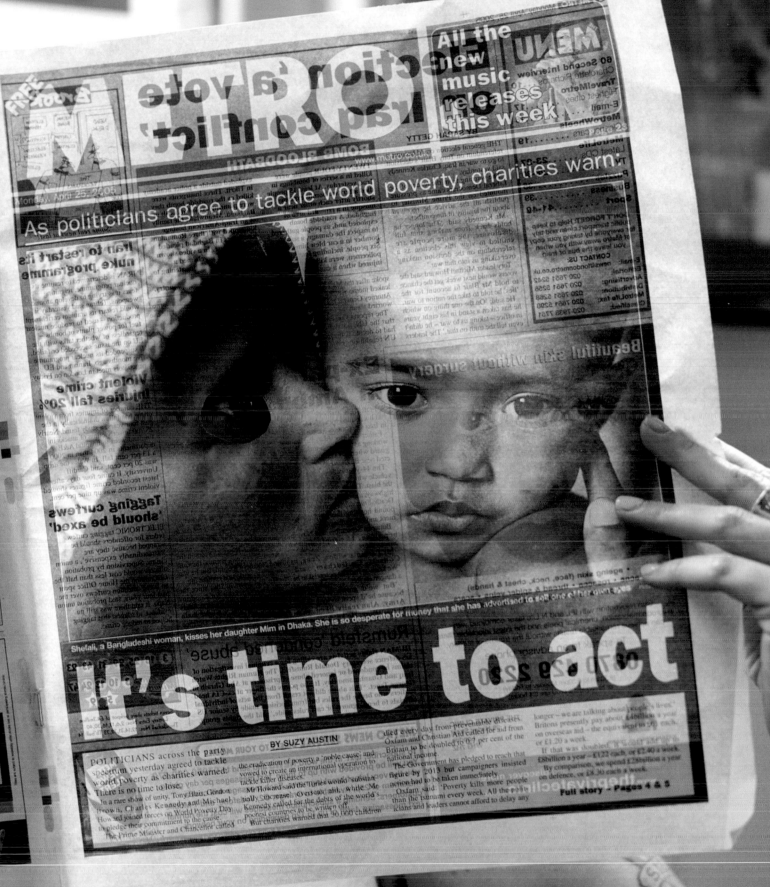

Shefali, a Bangladeshi woman, kisses her daughter Mim in Dhaka. She is so desperate for money that she has advertised it.

It's time to act

BY SUZY AUSTIN

POLITICIANS across the party spectrum yesterday agreed to tackle world poverty as charities warned.

There is no time to lose.

In a rare show of unity, Tony Blair, Gordon Brown, Charles Kennedy and Michael Howard joined forces on World Poverty Day to pledge their commitment to the cause.

The Prime Minister and Chancellor called

the eradication of poverty a "noble cause" and vowed to create an international operation to tackle killer diseases.

Mr Howard said the Tories would subsidise vital increases in overseas aid, while Mr Kennedy called for the debts of the world's poorest countries to be written off.

But charities warned that 30,000 children

died every day from preventable diseases. Oxfam and Christian Aid called for aid from Britain to be doubled to 0.7 per cent of the national income.

The Government has pledged to reach that figure by 2013 but campaigners insisted the action had to be taken immediately.

Oxfam said: "Poverty kills more people than the tsunami every week. All the politicians and leaders cannot afford to delay any

longer — we are talking about people's lives." Britons presently pay about £4 billion a year on overseas aid — the equivalent of 20p each, or £1.20 a week.

If that was doubled to £8 billion a year — £1.22 each, or £2.40 a week.

By comparison, we spend £28 billion a year on defence, or £8.30 each a week.

Full story – Pages 4 & 5

IT'S A GROWTH
INDUSTRY
Your business: Page 31

BUSINESS
BEGINS ON
PAGE 26

The Daily Tele

www.telegraph.co.uk FINAL

BRITAIN'S BEST - SELLING QUALITY DA

'To our unforgettable fa
may angels guide you to

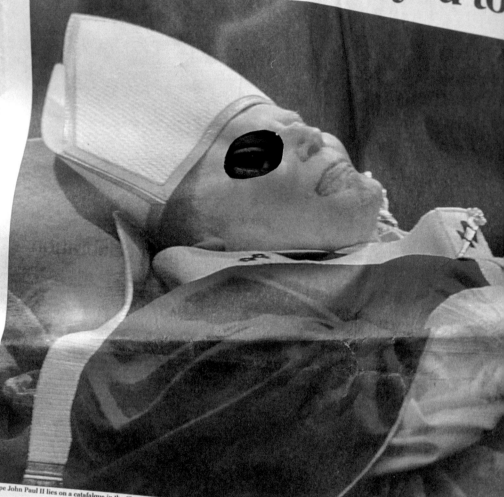

Pope John Paul II lies on a catafalque in the Clementine Hall of the Apostolic Palace yesterday where Church and state dignitaries paid their respects. Today his body will be

By PATRICK BISHOP
IN ROME

BY MID-MORNING at least 130,000 people had packed themselves into St Peter's Square yesterday. Still, there was a haunting feeling of emptiness in the huge piazza.

The sense of absence was brought home by the open windows of the papal apartment where John Paul II made his last, agonised appearance and which will never frame his reassuring figure again.

The men, women and children who flocked to the requiem Mass and continued to drift in and out all day were an illustration of the breadth and power of the Pope's message. Every nation on Earth seemed to be represented and goodness was in the air.

"We are Muslims but he was a man for all the world," said Mustafa Thaim, 35,

from Senegal, as he paid his respects with seven friends. "He wanted freedom and prosperity for everyone, whoever they were."

Martin Abilius, 30, standing under an Indian flag with a group of fellow workers, said: "He spoke out for us foreigners living in Italy. We came to show our solidarity with a great man."

The public mourning was a truly catholic occasion. Alongside the poor and oppressed there were chic, sleek Romans, wheelchair-bound ancients and small children gazing across the crowds from their perches on their fathers' shoulders.

At least half the crowd seemed to be made up of the young people whom John Paul held in special affection.

The day began at 10.30 with High Mass said in the open air from the steps of St Peter's by Cardinal Angelo Sodano, the

Vatican's secretary of state. "To our unforgettable father we say, may angels guide you to paradise," he declared.

"May a joyous choir welcome you and lead you to the holy city, to celestial Jerusalem."

Applause echoed around the square like a great wave breaking.

The congregation heard too the Pope's final message, written in preparation for this week's post-Easter Mass. It said: "It is love which converts hearts and gives peace. To all humanity which today seems so lost and dominated by the power of evil, selfishness and fear, our resurrected Lord gives us His love which for gives, reconciles and reopens the soul to hope."

The crowd seemed to have taken the message of redemption to heart. There were few tears: rather an awed appreciation of the gap in the spiritual life of the world that John

Paul's departure will leave. Everyone wanted a record of the occasion. In the intervals between the choir's singing, the air was filled with the chirrup of shutters as thousands of cameras and mobile phones captured the scene.

After Mass, the square emptied to be refilled by a stream of visitors. They stood in the warm sunshine saying the rosary, kneeling and praying or chatting softly with friends. Some had brought guitars and the rhythms of Polish and Spanish religious folk songs hung on the breeze.

Occasionally the wail of an ambulance siren served as a reminder of the huge task facing the police and emergency services in the days ahead when all roads will lead to Rome and the papal funeral.

Watched by television cameras far away from the public, dignitaries genuflected before the body of the Pope, laid out

in crimson and white vestments in the Clementine Hall of the Apostolic Palace.

This afternoon he will be moved to St Peter's where the public will be able to see him lying in state. It is thought that up to half a million people will file past his body.

"We loved him," said Nizidi, 33, from Eritrea, as she stood with her friends gazing up at the empty windows. "We are here to say goodbye."

Despite the public mourning, Italians went to the polls in regional elections that were seen as a key test for Silvio Berlusconi's ruling coalition.

In recent days, as John Paul's health quickly deteriorated, the campaign had been toned down and there were calls for it to be postponed.

But Giuseppe Pisanu, the interior minister, refused, saying: "The pain for the holy father cannot distract us from our duties as citizens."

Personal view

Pensions report is wrong to think savers are not rational, says Tim Congdon

MUCH of economic theory is concerned to establish that people are rational. For theoreticians and practitioners do not always see eye to eye. When confronted with real-world problems, economists are inclined to forget that they live in a world of rational agents.

Indeed, they are quite comfortable about offering recommendations to politicians which make sense only if people are rather silly. A good example is the recent report from the Pensions Commission, under the chairmanship of Adair Turner.

It says flatly: "Most people do not make rational decisions about long-term savings without encouragement and advice." The report pretends, from this patronising starting-point, to be concerned with worthy matters, largely in pensions provision, with a rise in the retirement age.

[remaining columns of article text not fully legible]

This is an extended version of a piece in the March edition of Economic Affairs, published by the Institute of Economic Affairs www.iea.org.uk

Prof Tim Congdon is chief economist at Lombard Street Research

the size of a normal bottle (6)
6 Seat of government and the administrative capital of the Netherlands (3,5)
7 One of about 39,000 species of arthropods that include wood lice, lobsters and crabs (10)
8 Sir John — English

17 Drury Lane orange seller and actress who became a mistress of Charles II, among others (4,4)
18 A red dye that was originally obtained from madder root (8)
21 A partially dried grape (6)
23 Light, fast sailing ship that was used in coastal patrols (6)
24 In archaeology, a roughly shaped flint that is thought to be a man-made tool (6)
26 The western Pacific island, capital Agana, southernmost of the Marianas islands (4)

Solutions in the tinted squares, with highlighted clues, will join up with solutions from Saturday's Giant General Knowledge Crossword to make four well-known words or phrases. To enter, send the grid with your name and address to: **Herculis Crossword, Box No 601, London E14 5FD**. Entries must reach us by first post on Thursday. **The first correct entry drawn will win £500.** The solution and winner's name will be published next Monday.

Last week's winner: Betty M Brooks, Nailsea, Bristol.

Last week's solutions
Across: 7 Snowdrop, **9** Halvah, **10** Saint Kilda, **11** Ritz, **12** Upper, **13** Esplanade, **15** Diktat, **16** UNISON, **19** Ayckbourn, **21** Falls, **24** Mews, **25** Animal Farm, **26** Size up, **27** Excerpt. **Down: 1** Encamp, **2** Swan neck, **3** Brake, **4** Shearling, **5** Florin, **6** Mastodon, **8** Polish, **14** Savoy Alps, **15** Day Lewis, **17** Stanford, **18** Ermine, **20** Kosher, **22** Larkin, **23** Canon. **Linked solutions:** VICTORIA FALLS; UPPER CRUST; FRENCH POLISH; ERMINE STREET.

FEATURES

Women of letters

Extracts from 'And God Created the Au Pair' by sisters Bénédicte Newland and Pascale Smets Page 15

How to shine in interviews

With good preparation and clever body language, getting that job is simple Page 16

SPORT

Loathsome Lee

Anger infests Bowyer's simple mind. He could get sent off playing solitaire Henry Winter 51

NEWS

Plea on abortions

The Marie Stopes clinic

Election campaign starts tomorro
but swing to Tories will not oust B

By GEORGE JONES
POLITICAL EDITOR

The campaign leading to a general election on May 5 will be launched tomorrow with the latest poll showing a three per cent swing from Labour to the Conservatives since 2001 enough to dent but not overturn Tony Blair's majority.

the Tories is most marked in London, which has many marginal seats, at seven per cent. In the North it is six per cent, but only one per cent in the South East and South West.

In Scotland there is a five per cent swing from Labour in the Scottish National Party.

A sustained three per cent swing across the country would take Labour to the brink of losing its majority as the largest in

has a majority of only 1,414 in Dorset West.

Labour MPs are likely to be alarmed by the indication that many working-class voters no longer identify with New Labour. The gold per cent among manual workers and their families is the largest in any demographic group, the

at Westmin
this afternoo
tributes to th
Lord Callagh

Michael
Charles Ke
attend the s

34

INTERNATIONAL

Herald

THE NEW YORK TIMES EDITED IN

THE WORLD'S DAILY NEWSPAPER PUBLISHED BY

WEDNESDAY, DECEMBER 15, 2004

Thomas Fuller: Danes n
hiring and firing seem

THE **WORK** PLACE

BUSINES

By ROGER COHEN
Looking back over a century

PAGE TWO

Turkey offers a test of EU multiculturism

Wary public may hurt Ankara's dreams

By Graham Bowley

AMSTERDAM: Call it bad timing, or just bad luck. As the date nears for a decision on membership negotiations with the European Union, it is Turkey's misfortune that it is seeking to enter this exclusive, mainly Christian, club at a time when many Europeans believe they are witnessing the failure of multicultural society in Europe.

Many think this should mean the death of a multicultural EU as well. And while European leaders will most likely say yes to Turkey on Thursday or Friday in Brussels, it will be a reluctant yes, reflecting the views of a growing number of EU citizens.

The shift in perceptions is particularly palpable in the Netherlands, where the political climate was transformed last month by the murder of the filmmaker Theo van Gogh by a killer who slit his throat and pinned to his chest with a knife a text calling for Muslims to rise up against "infidels."

In Amsterdam last week, as cyclists pedaled past canal houses outside, 12 Dutch visitors at the Anne Frank house were asked for their views on Muslim integration into Dutch soci-

ety. They were told to press a green button if they thought it was fine for politicians to criticize Muslim immigrants who did not adopt Dutch practices, or to press a red button if they thought this amounted to discrimination.

Feelings of guilt over the treatment of Jews in World War II, as well as a strong liberal commitment to a multicultural society in the Netherlands, would have forbidden criticism. But this time, when the visitors pushed their buttons, green lights illuminated the room.

In the famously tolerant Netherlands, it was a vote for a little less tolerance, a victory for a tougher line against those immigrants who, many Dutch believe, are unwilling to embrace core Dutch values.

"People believe in an emotional way we are losing so much of our European identity," said Hans Westra, director of Anne Frank House. "We are looking for some new basic values to keep us together as a nation, not values from the Middle Ages that we fought for so long to get rid of."

TURKEY, Continued on Page 10

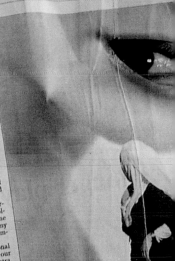

Two Muslim women in traditionally tolerant Amster
Muslim Turkey into the EU. Turkey's bid for member

Abbas calls for end to th

By Greg Myre

JERUSALEM: Mahmoud Abbas, the favorite to win next month's Palestinian presidential election, said in an interview published Tuesday that the armed uprising against Israel was a mistake and must end.

"The use of weapons is harmful and it should stop," Abbas told Asharq al-Awsat, a leading Arabic-language newspaper that is published in London.

Abbas has made such statements in the past, but it was his most explicit condemnation of Palestinian violence recently and signaled his intention to

chart a different strategy following the death of Yasser Arafat a month ago.

Abbas, 69, has succeeded Arafat as chairman of the Palestine Liberation Organization and faces no serious challengers in the Jan. 9 election for the presidency of the Palestinian Authority.

While Abbas has been willing to speak out against Palestinian violence more so than any other Palestinian leader, he has not indicated that he would use the Palestinian security forces to crack down on factions that continue to carry out attacks.

His remarks appeared two days after Palestinians killed five Israeli soldiers

UPDATE

2 causes found in Concorde crash

A French legal inquiry into the Concorde crash near Paris in 2000 presented findings Tuesday that put part of the blame on Continental Airlines, exposing the U.S. company to a criminal lawsuit and multimillion-euro compensation claims. After a four-year inquiry, the report concluded that the cause of the crash was twofold: a structural fault in the Concorde's design, and a titanium metal strip left lying on the runway from a preceding Continental plane. *Page 3*

Inuit blame U.S.

The Inuit, 155,000 seal-hunting peoples scattered around the Arctic, plan to seek a ruling from the Inter-American Commission on Human Rights that the United States, by contributing substantially to global warming, is threatening their existence. The Inuit plan is part of a broader shift in the debate over climate change. *Page 5*

CURRENCIES | New York

	Tuesday 4 P.M.	Previous
€1 =	$1.3304	$1.3308
£1 =	$1.9283	$1.9249
¥ =	¥105.63	¥104.875
$1 =	SF1.154	SF1.154

Full currency rates | Page 14

OIL | New York

Tuesday 4 P.M.

Light sweet crude $41.82 ▲ $0.81

STOCK INDEXES

Tuesday

The Dow 4 P.M.	10,676.45	0.36%
FTSE 100 close	4,722.80	0.30%
Nikkei 225 close	10,915.58	1.17%

On the Web: www.iht.com

In this issue	No. 37,875	
Books		11
Crossword		11
Opinion		8-9
People		

In Qaddafi's

Libyan says 'democr

By Craig S. Smith

TRIPOLI, Libya: Seif el-Islam Qaddafi, the son of this country's idiosyncratic leader, was just 14 in 1 when American bombs destroyed home and killed his 4-year-old si Despite that harsh experience, he emerged in the past few years new, Western-friendly face of former pariah state.

His fingerprints are on almost major international move the c has made since it began its rec bilitation, from compensating fam ilies of victims of past terrori to abandoning the program to unconventional weapons. cy in a part of the world whe men have long been the nor

"Democracy is the futu 32, said at his Moroccan-st side Tripoli, where he keep Freddo, among other

Seif el-Islam el-Qaddafi, 37, rejects any suggestion of his succeeding his father.

When 'Europe' is no

By Don Phillips

PARIS: Just a few months ago, a company with "European" in its name and one foot firmly planted in France could never hope to win a huge American military contract. But a few interesting twists of fate have intervened.

Pentagon is
EADS a 2nd

But that was be cial and politica years, and nuclear Market has a fighting cha

(Cities weather tables — Africa, Asia/Pacific, Middle East, North America, Central and South America, Europe, Oceania)

Europe

Increasing winds from the Atlantic will cause showers to increase in northern Europe during the last half of the week. Heavier rain will develop on Friday in central France while snow begins in the Alps. Meanwhile, locally heavy showers will cross the eastern Mediterranean.

Asia/Pacific

North Korea and eastern Russia will be snowy late this week as showers cross much of Japan. Cold air will cover Mongolia and Manchuria. Meanwhile, south-central China will be mild. Rain and wind will surround Tropical Storm Talas in the eastern Philippine Sea.

e Calvados

It's the little things we remember.

Kristen Baloch/The New York Times

base cider is blended from dozens of obscure varieties that tend to be bitter and acidic and so good for pies but just right for the alchemy of distillation.

While Normandy is the spiritual home of Calvados, the United States is not without its own tradition of apple brandy. Apple brandy dates to Colonial days, and the oldest distiller in the United States, Laird & Co. of Scobeyville, New Jersey, makes both a youthful $20 apple brandy, and a 12-year-old $50 version. While the younger bottle did not make our list, we liked its spicy, minty apple flavors well enough. The older bottle lacked the same apple character. Laird also makes applejack, a more distinctively American name, which blends apple brandy with neutral spirits.

The only American brandy to make our list came from Clear Creek Distill-

What's better than flying?

☑ Spending more time with your family, made possible by Online Booking!

Now you're really flying.

CATHAY PACIFIC

We'd like to propose a toast.

☑ To our chefs, for knowing that garlic bread would be such a treat at 30,000 feet.

Now you're really flying.

CATHAY PACIFIC

Many languages, one meaning.

Half-full or half-empty?

Willkommen

Welcome

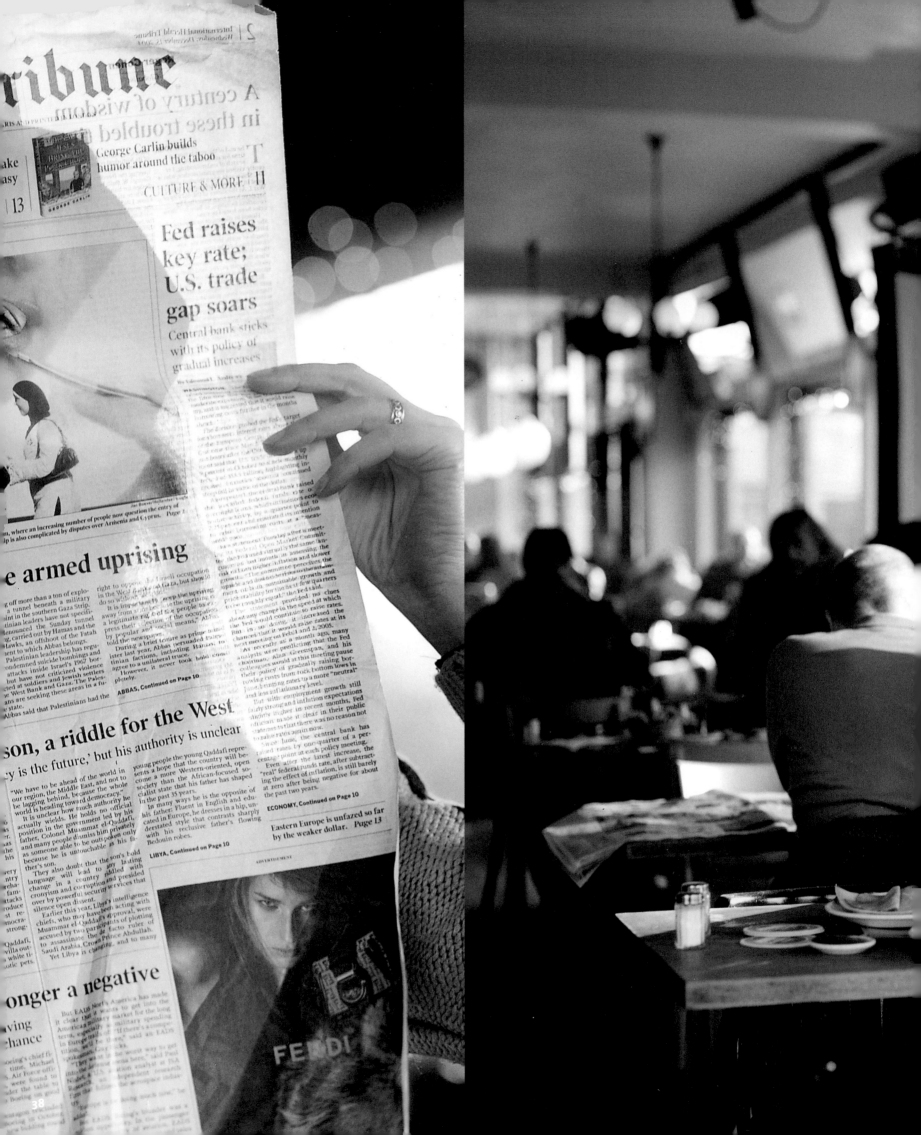

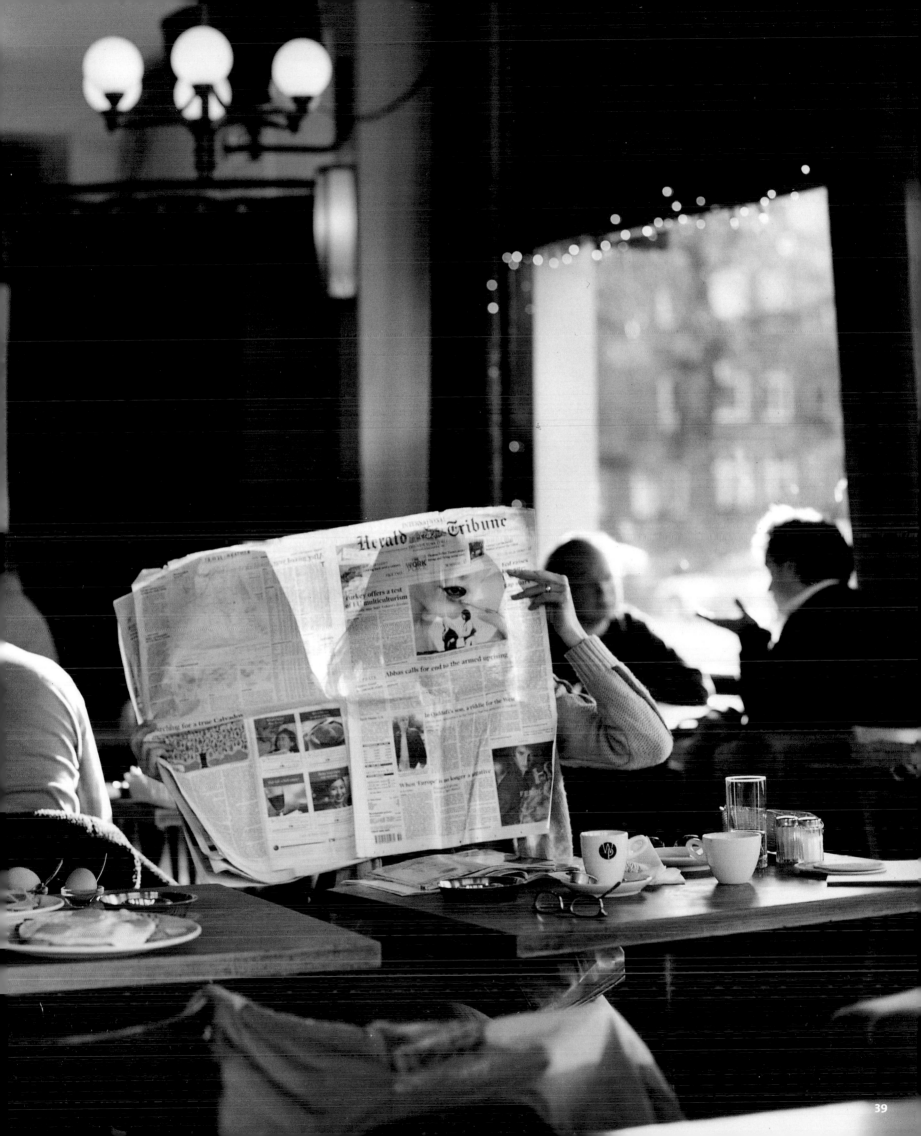

WS SOURCE
RLD REPORT
WS
FEBRUARY 28, 2005

MMB

CIOUS REALLY
ECISIONS

#BXNMCYW ********CAR-RT LOT**C-084
#020DA00215698012# 10 DA SS13F 853953
THOMAS J CONNOLLY P179
 FEB08 525
 029E 953
654 MADISON AVE NY 10021-8404
NEW YORK
 www.usnews.com

Business city comment

missions trading will
20pc to power bills

A bank of id

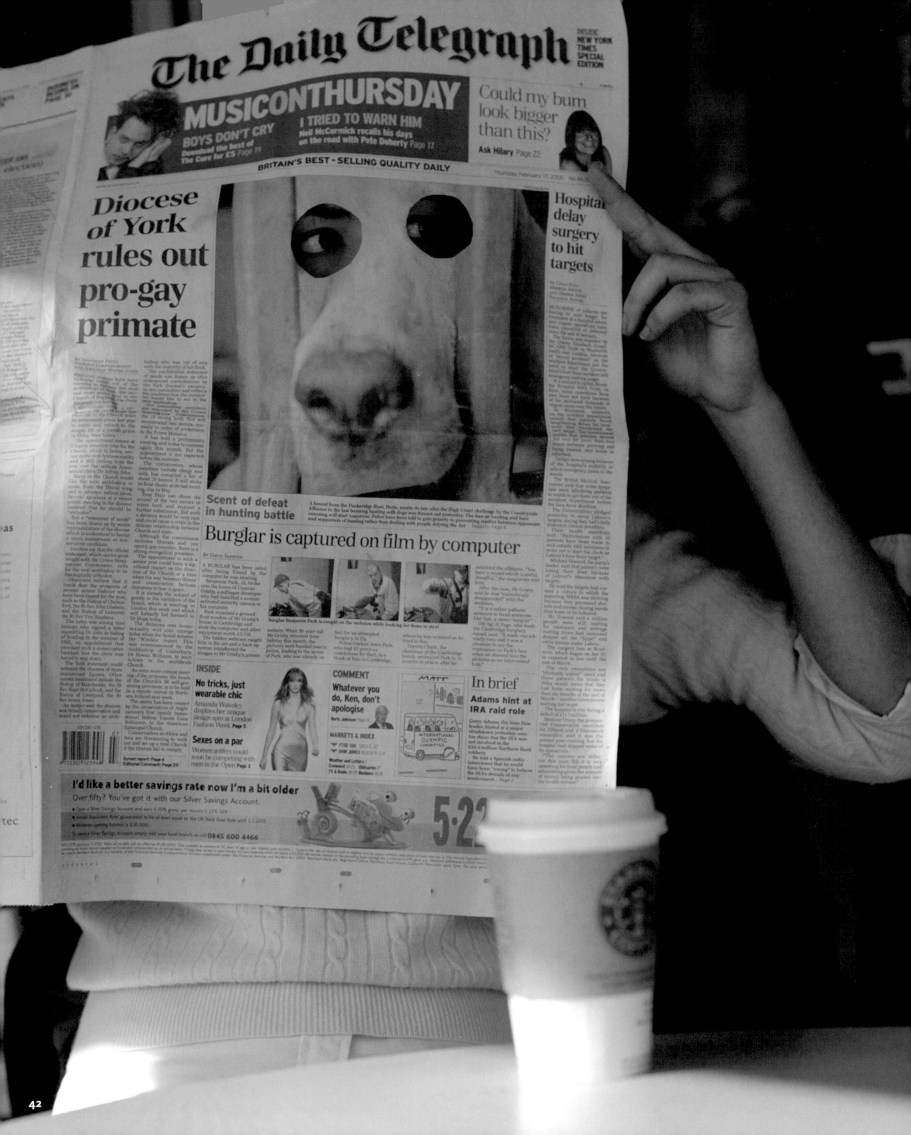

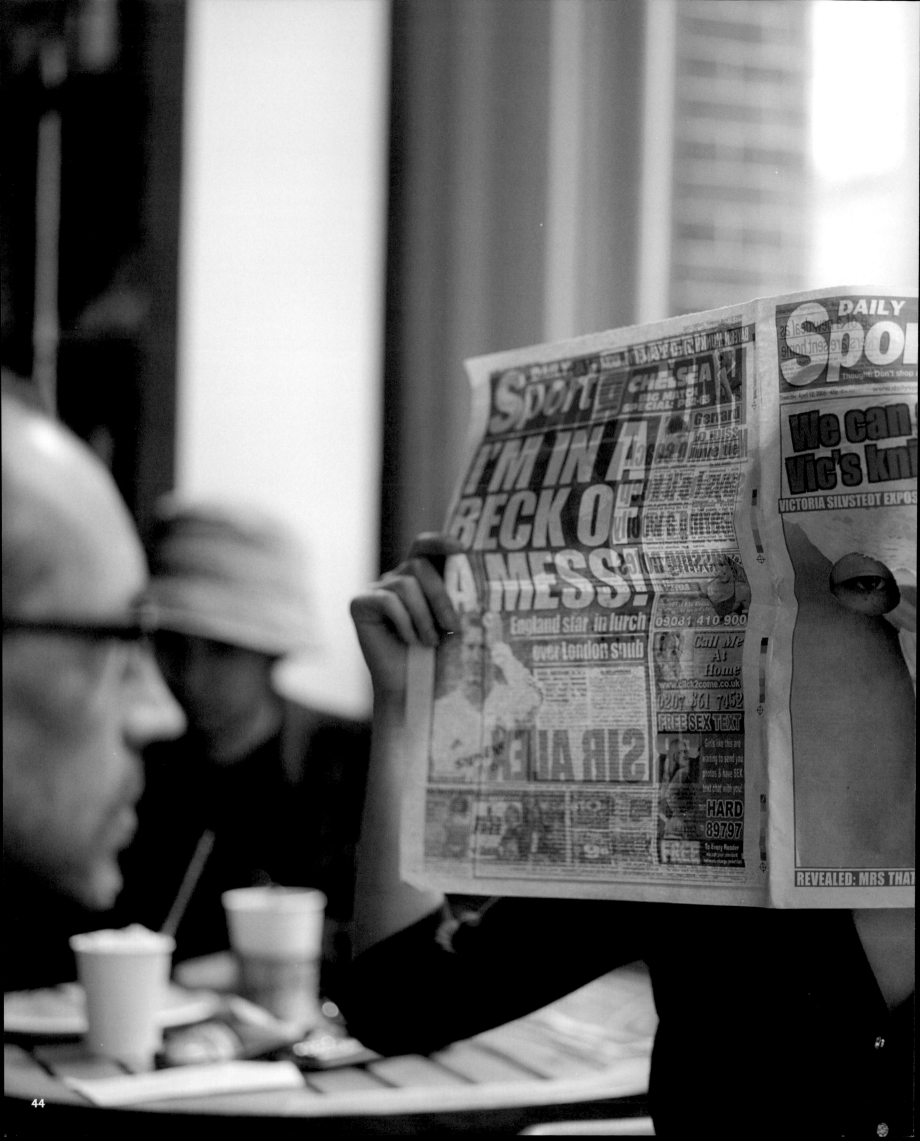

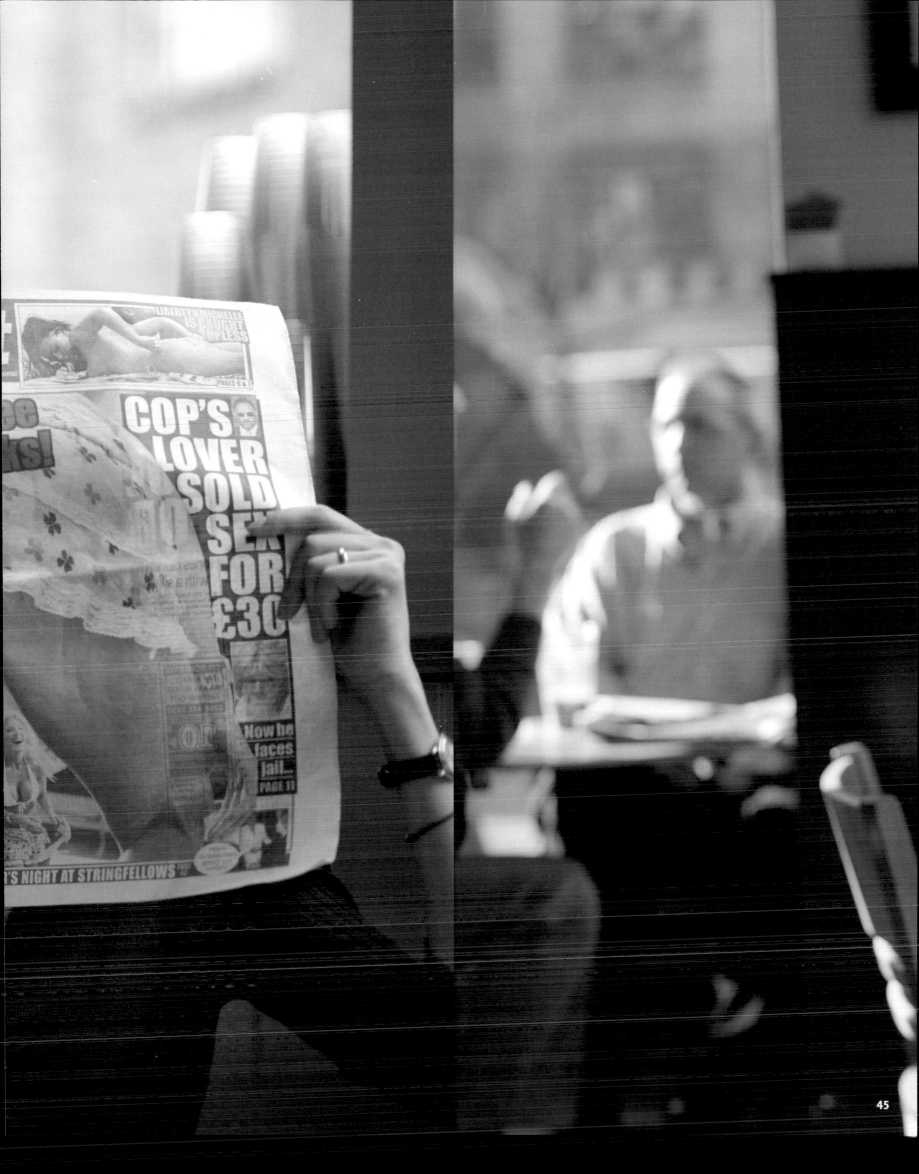

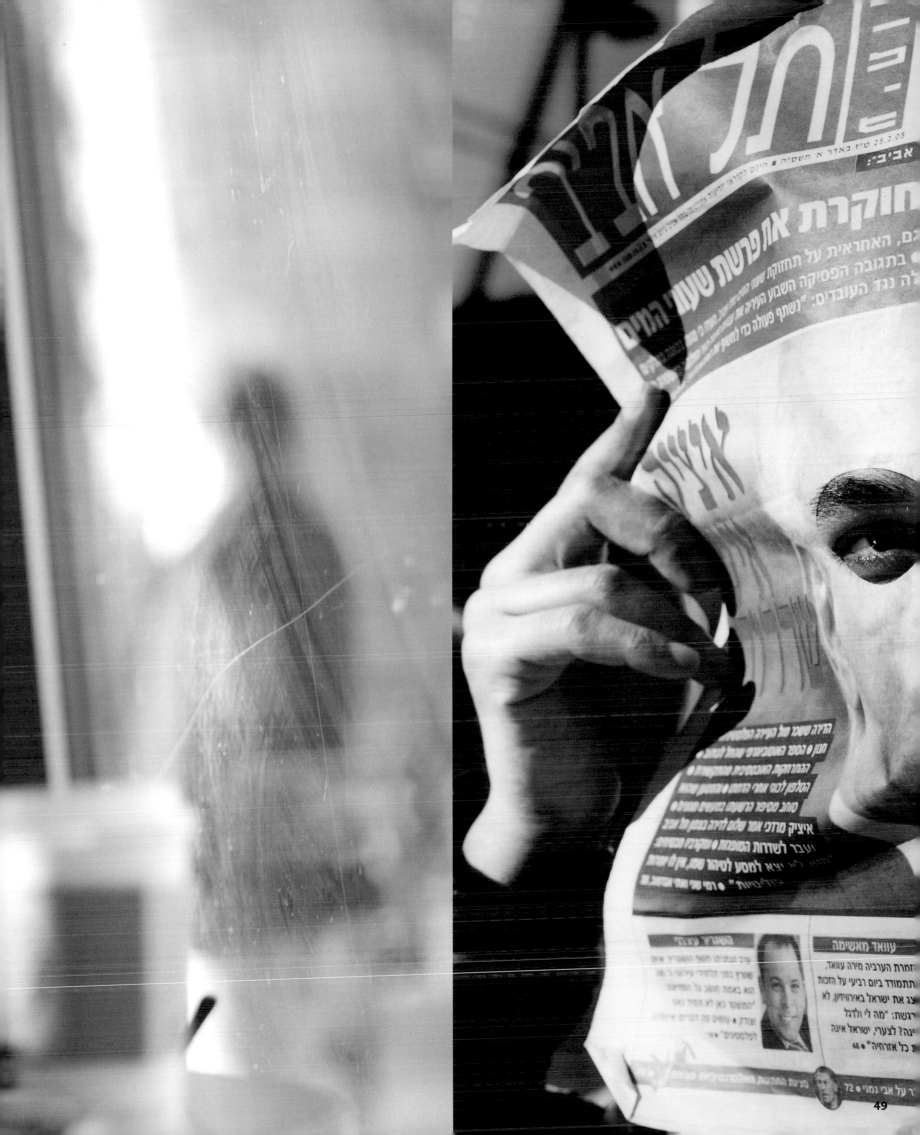

LE SOIR

LES livres DU SOIR
Redécouvrez
Paula Fox

LES routes DU SOIR
La nouvelle
Citroën C4

Manu Chao, un livre, un disque

Page 25

Édition Namur/Luxembourg • Vendredi 5 novembre 2004 • Quotidien • N° 259 • EUR 0,90 (G.-D. L. : EUR 0,95) • www.lesoir.be • 02 225 55 55

L'après-Arafat a comm

■ Le vieux « raïs » palestinien était donné jeudi pour cliniquement mort. ■ Dirigeants israéliens et palestiniens sont prêts au pire. ■ Tout est possible : le chaos... ou un nouveau départ.

TEL-AVIV

A
par la télévision israélienne et repris par le Premier ministre luxembourgeois Juncker au sommet européen de Bruxelles, a rigoureusement été démentie par les services religieux français. Mais en définitive, s'est convaincue personne.

En Israël, dans les territoires palestiniens, partout dans le monde

de, la nouvelle de l'aggravation de l'état de santé du président de l'Autorité palestinienne s'était répandue depuis jeudi matin.

Informés d'heure en heure par l'Aman, le Mossad et le Shabak, l'ensemble des services de renseignements israéliens, Ariel Sharon et son ministre de la Défense

Chaoul Mofaz avaient déjà, dans le courant de la matinée, ordonné à l'armée et à la police d'appliquer les premières phases des plans spéciaux anti-émeutes élaborés pour le jour du retour du corps du vieux « raïs » et pour celui de son enterrement.

Dès l'annonce de la nouvelle, et alors que les communiqués infirmant ou confirmant la mort du président palestinien se multipliaient, les radios et télévisions de l'État hébreu, ainsi que celles des pays voisins et les grands réseaux satellitaires, ont en tout

cas interrompu de leurs émissions leur attention sur le Yasser depuis une sem ge dans un c sonne, ni à Jér riah, ne sembla dre à la que pourtant le m

Sollicité p journalistes, Knesset, a r sur la dispar souvent prés Laden pales

Révolution dans les villes wallonnes

SANS DÉBAT

Q

Le vaste programme de George W Bush II

NATHALIE MATTHEIEM,
envoyée permanente
NEW YORK

A
peine réélu, George Bush « presente » ses ambitieux projets pour son second mandat, lors d'une conférence de presse à la Maison Blanche. Il affiche son souhait de rassembler le pays sur ses objectifs.

Le président américain, à présent sûr d'un mandat reconduit et d'une majorité nombreuse

au Congrès, s'est réjoui du caractère rafraîchissant d'une élection qui lui a permis de présenter son dossier, encore et encore et d'avoir prescrit l'impression que les gens sont certains et ont approuvé ses vues.

Il compte agir rapidement : j'ai gagné un capital que je compte dépenser pour mon programme, dit-il.

Au menu : l'Irak et de nombreuses priorités intérieures, économiques et sociales. •

Bar
sa c

PASCAL M
PHILIPPE F

L
so, présen midi ou t ques du la nouvelle

Il a an du nou xelles u ville éq deux n l'italien ton And ger de Lazlo gie pou

Ces grès vo

QUATRE PAGES SPÉCIALES

mencé

cours normal
s pour focaliser
l'hôpital pari-
ne. Mort ? Plon-
profond ? Per-
lem ni à Ramal-
apable de répon-
on, qui obsédait
e entier.

des dizaines de
ron, en visite à la
é se prononcer
n de celui qu'il a
é comme « le Ben
en ». Il s'est con-

tenté d'une déclaration lapidaire selon laquelle *Israël ne s'occupera pas de cette affaire tant qu'une annonce officielle n'aura pas été faite par les personnes concernées.* Mais son air heureux, et la mine enjouée qu'il affichait devant les caméras, en disait plus long qu'un discours.

Le soulagement était également manifeste au ministère israélien des Affaires étrangères. ●

Suite page 11
Editorial page 2

TROIS PAGES SPÉCIALES

oso recycle mmission

N
NIER

dent de la future
ssion européenne,
anuel Durao Barro-
a ce vendredi après-
's des groupes politi-
ement européen sa
ipe remaniée.

cé jeudi soir en mar-
t européen de Bru-
position de sa com-
Celle-ci comporte
eaux commissaires,
nco Frattini et le Let-
iebalgs, et fait chan-
tefeuille le Hongrois
cs, qui laisse l'Éner-
ndre la Fiscalité.

s commissaires dési-
devoir subir une audi-
et les co

lementaires compétentes. Les modalités et les dates des auditions seront fixées vendredi par M. Barroso et les présidents de groupes.

Le vote d'investiture de la Commission devrait probablement avoir lieu lors de la prochaine session plénière du Parlement prévue du 15 au 18 novembre à Strasbourg, selon des sources concordantes.

Rappelons que M. Barroso avait été contraint la semaine passée de retirer sa précédente équipe, pour éviter un humiliant refus d'investiture du Parlement européen en raison de la crise provoquée par les prises de position controversées du candidat commissaire italien Rocco Buttiglione. ●

Page 14

LE SOIR

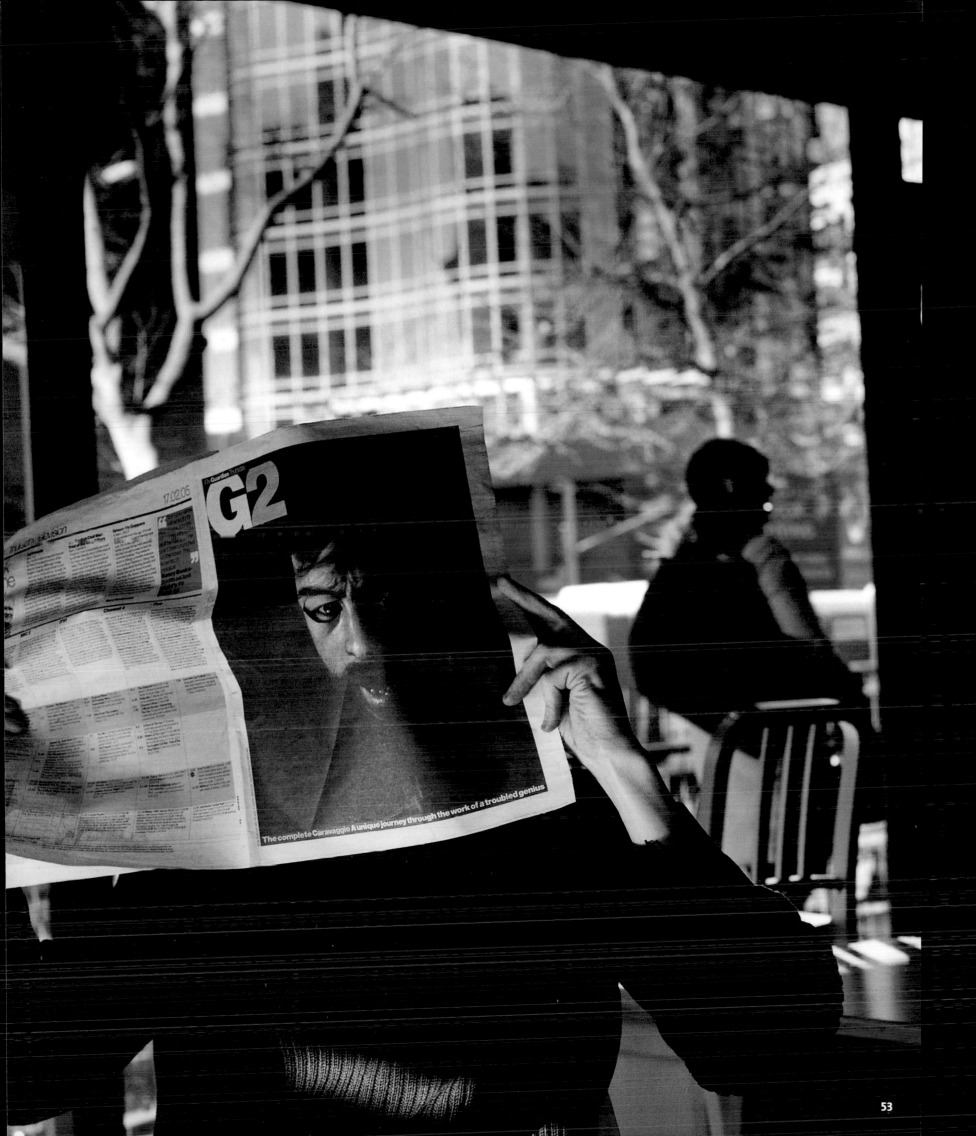

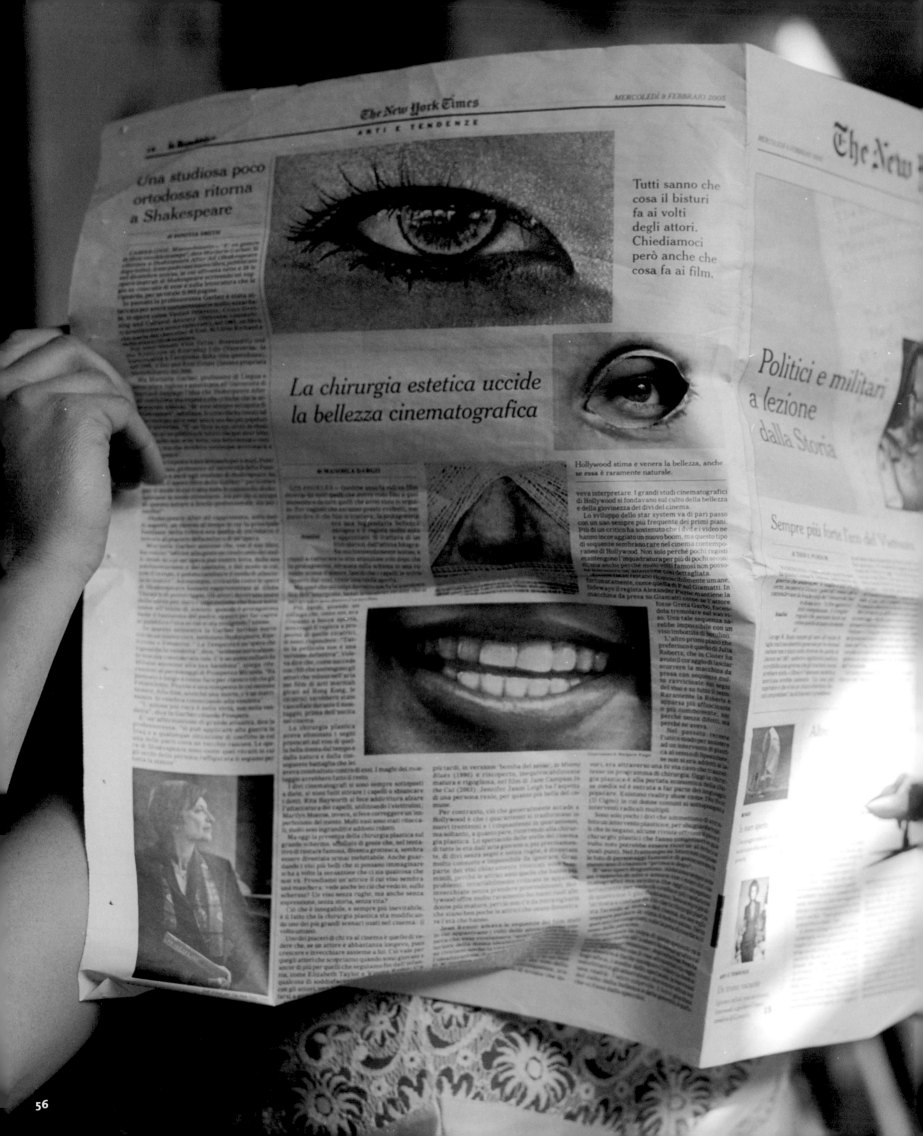

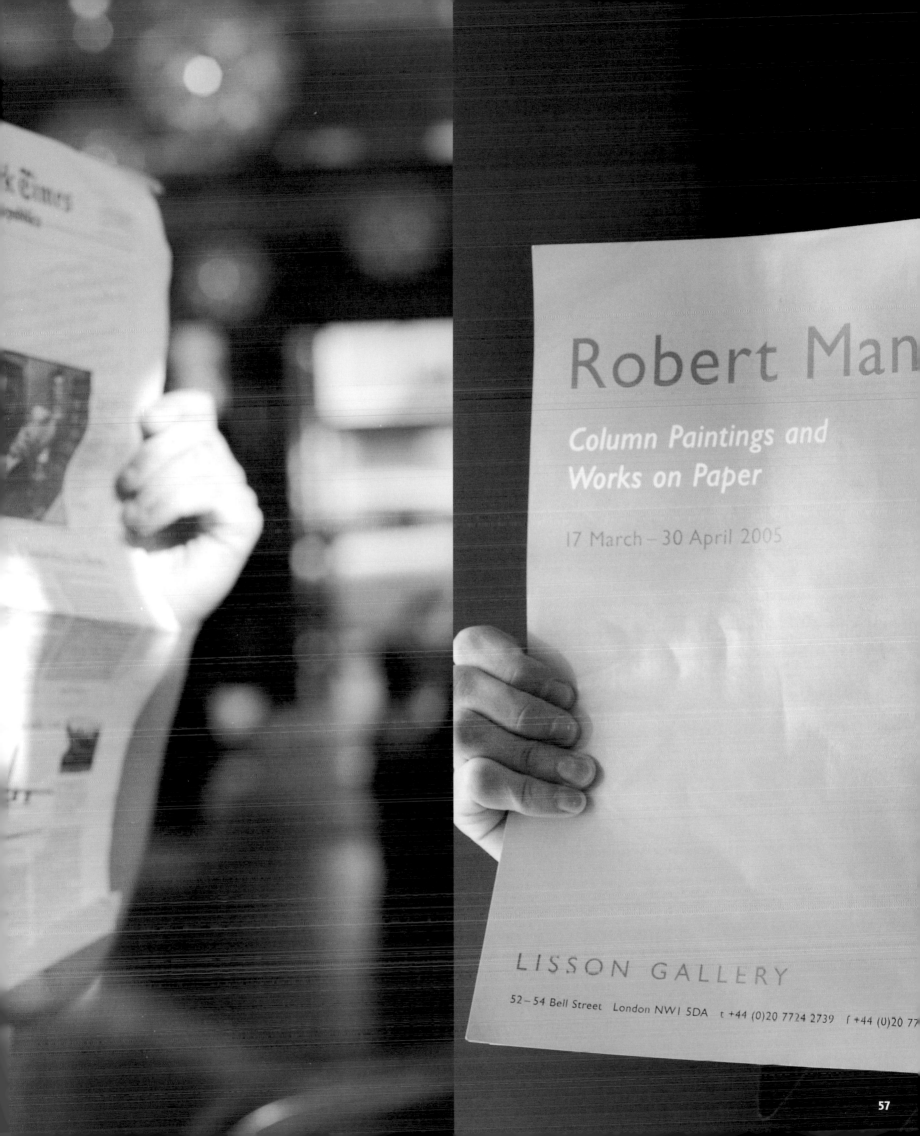

gold

www.lisson.co.uk

frieze

Issue 89 March 2005

Michaël Borremans Paulina Olowska Thomas Schütte Interview: John Stezaker

www.frieze.com

frieze

Michaël Borremans Paulina Olowska Thomas Schütte Interview: John Stezaker

Contemporary Art and Culture Issue 89 March 2005 UK £4.50 US $9.50

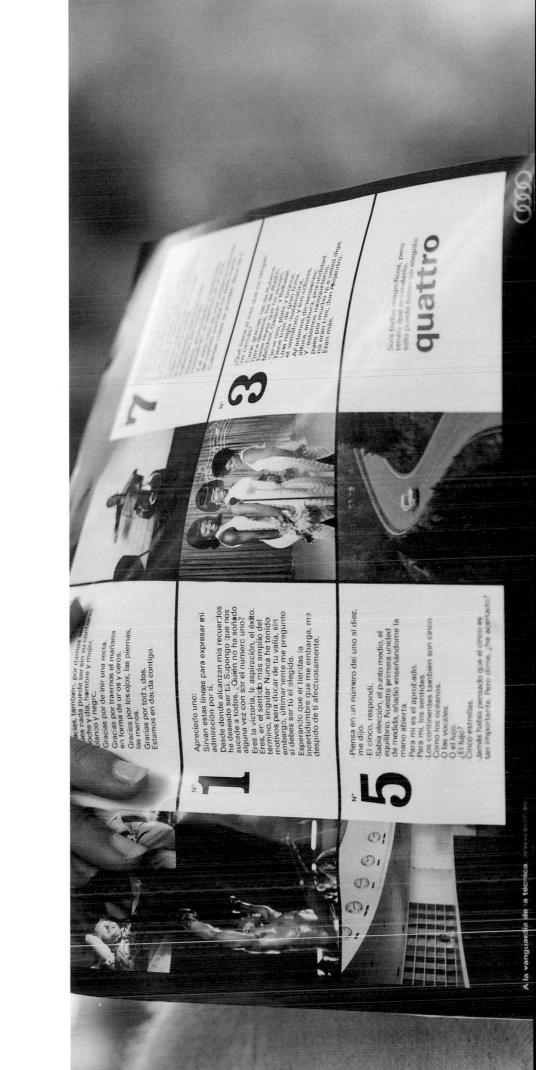

NOVIEMBRE 2004 ● Nº 282 ● 2,50 EUROS (Spain only)

muy INTERESANTE y

www.muyinteresante.es

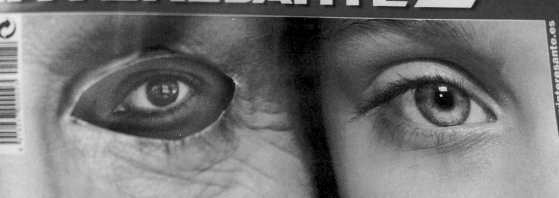

DOCUMENTO 16 páginas

Cómo vivir
100 años
(y disfrutarlos)

LOS VIKINGOS
Navegantes, guerreros...
y comerciantes

Y ADEMÁS:
● **Por qué mueren
las palabras**
● **MOMIAS DE CULTO**
Lenin, Evita, Mao...
● **CIENCIA**
Así copiamos
los diseños de
la naturaleza

FOTOS ÚNICAS
La Tierra, vista desde
la Estación Espacial

NEUROPSICOLOGÍA
¿Podemos leer el
pensamiento de otros?

Printed in Spain • Canarias: 2,65 euros (sin IVA), incluido transporte • Alemania: 6,10 € • Austria: 6,60 € • Bélgica: 4,... € • Francia: 3,80 € • Grecia: 3,85 € • Luxemburgo: 6,60 € • Reino Unido: 2,95 GBP • Suiza: 7,50 CHF

60

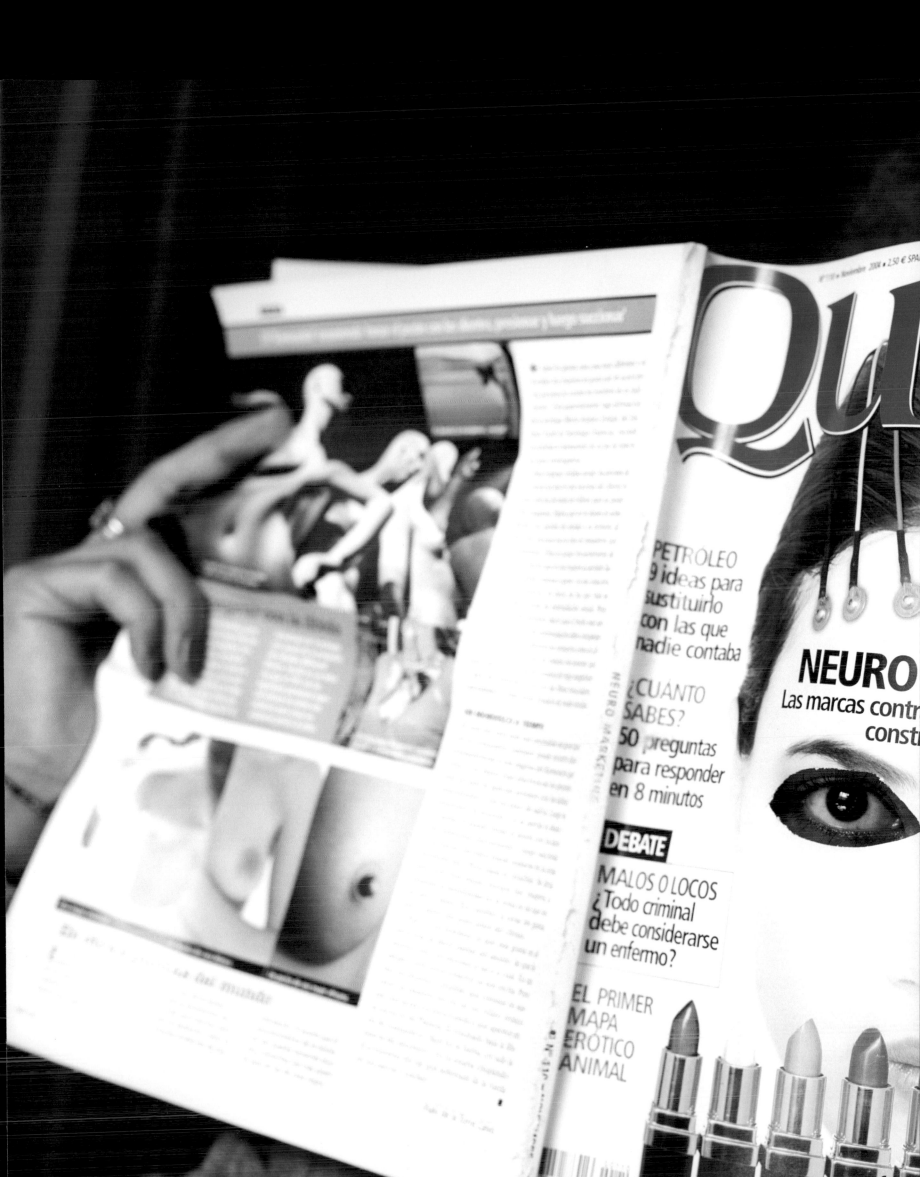

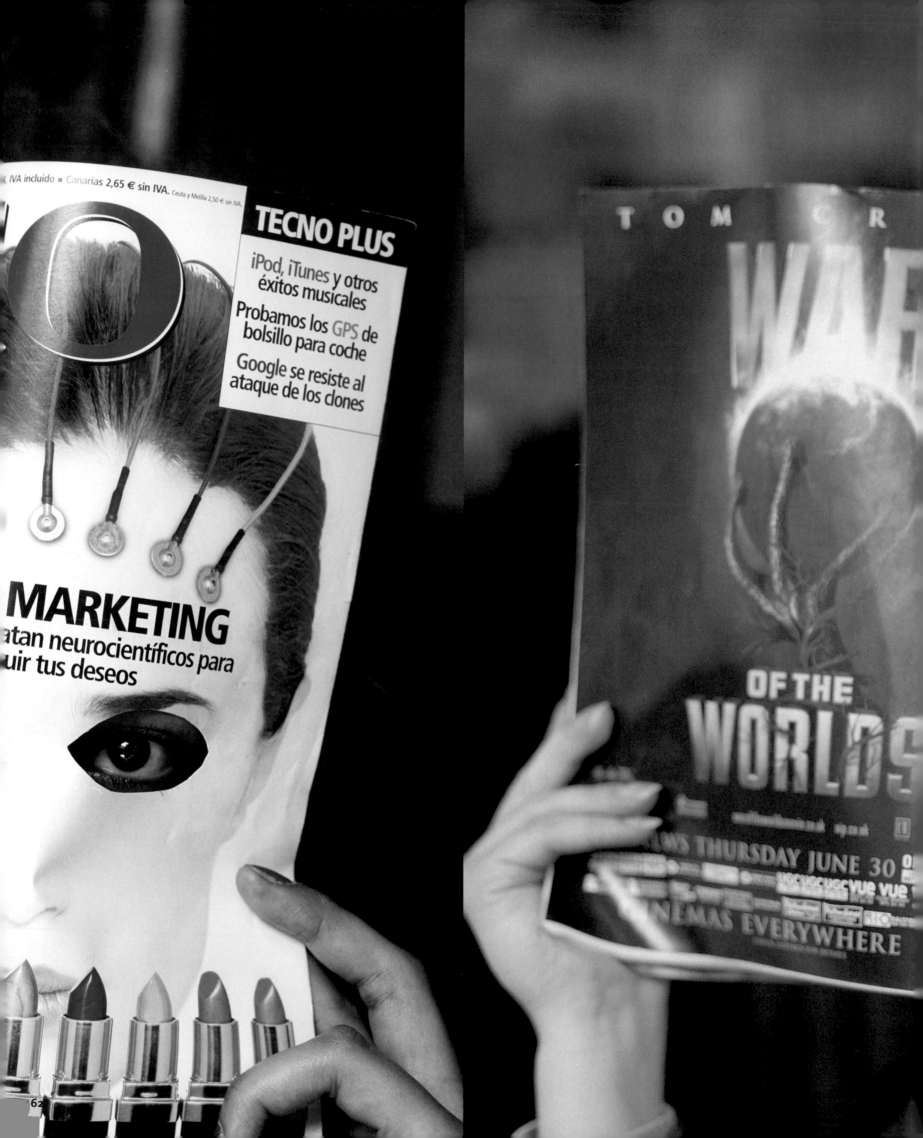

LE SOIR

Manu Chao, un livre, un disque, une rencontre

L'après-Arafat a commencé

■ Le vieux « raïs » palestinien était donné jeudi pour cliniquement mort. ■ Dirigeants israéliens et palestiniens sont prêts au pire. ■ Tout est possible : le chaos... ou un nouveau départ.

Révolution dans les villes wallonnes

Le vaste programme de George W Bush II

Barroso recycle sa commission

Duval reste attiré par Citroën... qui arrêtera fin 2005

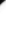

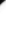
65

The complete Caravaggio A unique journey through the work of a trouble

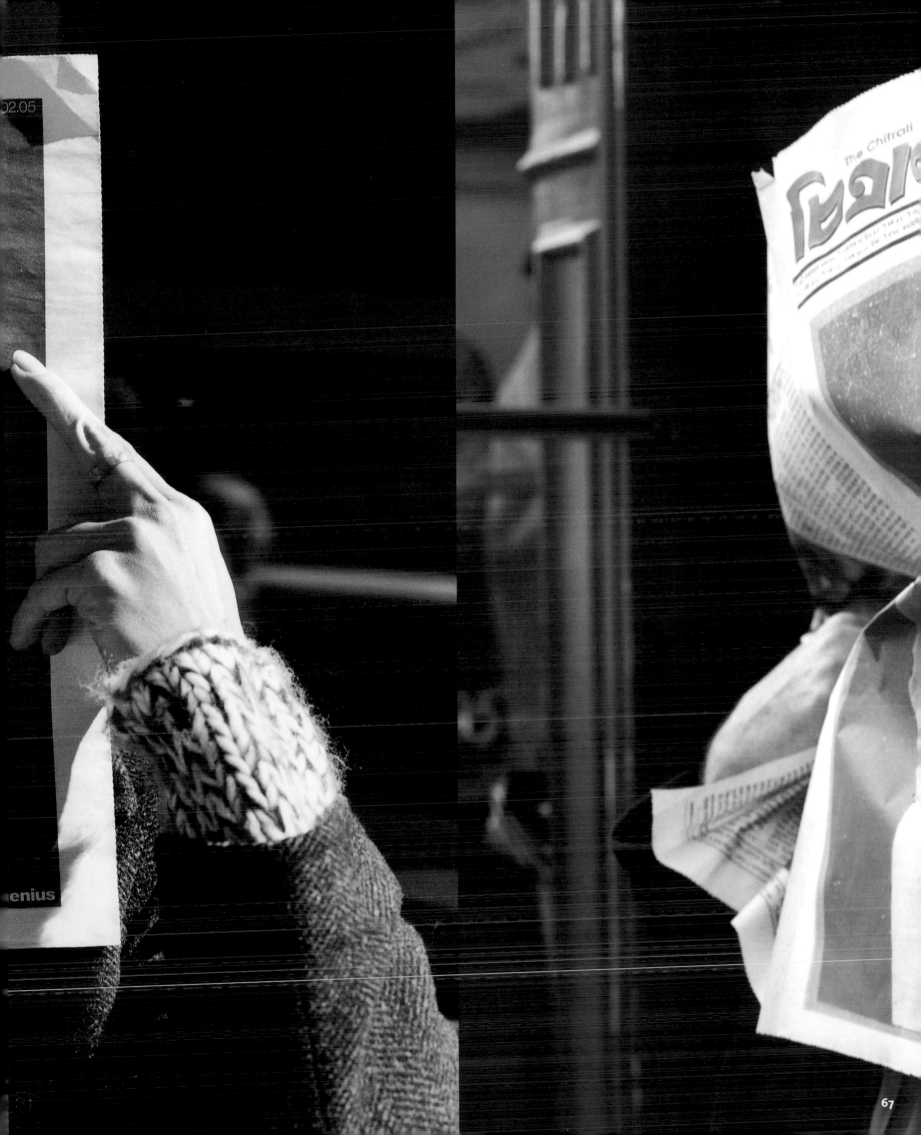

ée inédite dans ses
ves personnelles

RIL 2005 - N° 490

es

> Damien Hirst

> Morrissey
 & The Smiths

> Philippe Katerine

> Regina Spektor

BAIN

SANT

nt
re

MERCREDIS 3 €

1154-490-F.3€

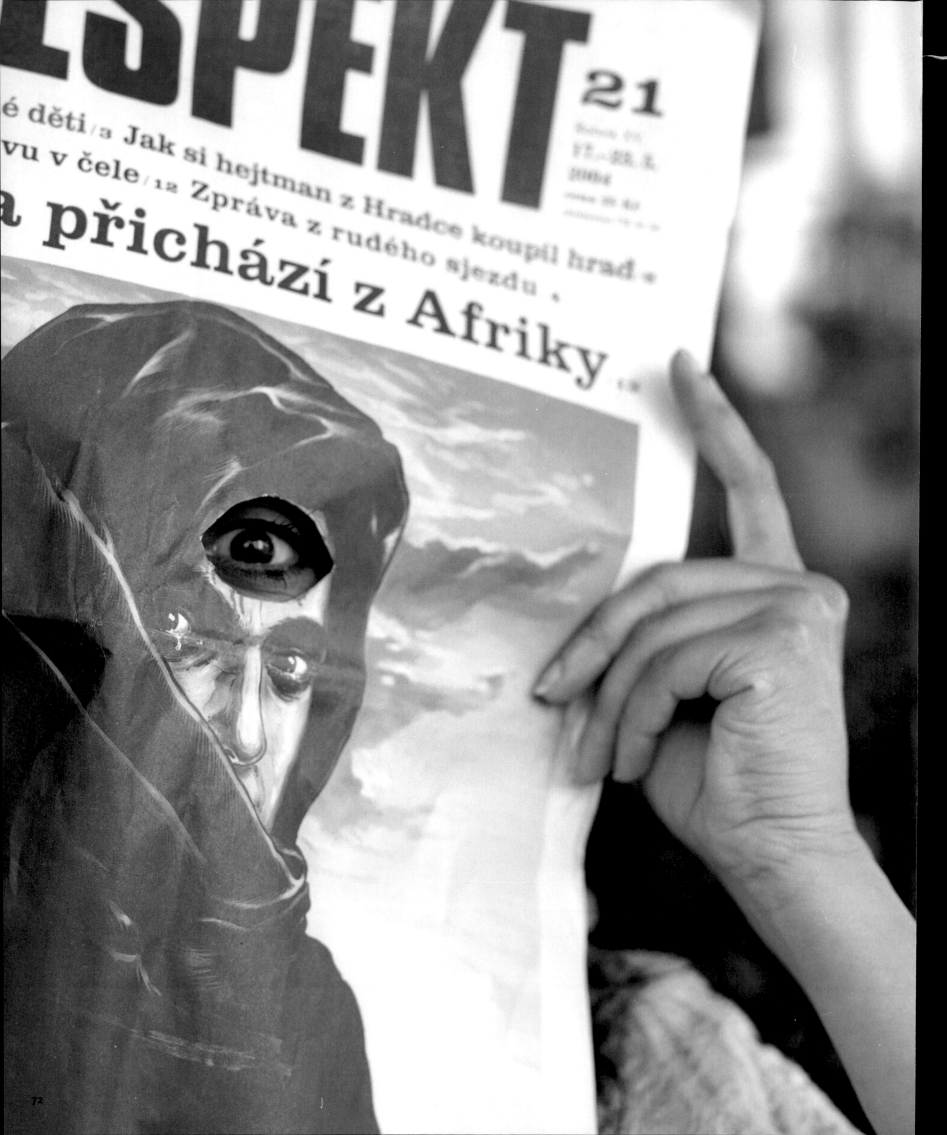

مواقفه اليسارية الجذرية المعادية لليبرالية المتوحشة

الشاعر الفرنسي تاركوس صاحب الكلمة «العجينة»!

الفنتازي والواقعي في «قبل أن تنام الليلة» لأحمد العبدلاوي

محمد أحمد المسعودي *

[إلى المبدع عبد اللطيف الزكري]

■ خلخت القصة المغربية الجديدة، واصطلحت على بعض خطوات متنوعة، اجترحتها بميزات متنوعة وتطوراتها وتأتي تجربة الواقع بدلالات جديدة القصيرة لتضفي على مسار القصة، وعلى الرغم من أن هذا المتن يعني بعض خاصة العبدلاوي في مسار القصة الامكانات الفنية يتميز بالغنى أفقا يمثل الكثير من سمات التفرد. ومن هنا يرسم لنفسه الذي يتميز بالغنى والخيالية والتنوع الكبير من خلال هذه الليلة.

إن أول ما يلفت نظر قارئ القراءة الفني هو البعد الفنتازي الساخر الذي يعانق قصص أحمد العبدلاوي مع تعانق الخرافي التي تولدها صيغ تعميمه في عالميته من الغربية. انها فنتازيا تنفتح على الواقع وتمتد الى لتضخيم تخييلية رحبة السخرية والتجريب اللاذعين في اللعب اللغوي...

كريستوف تاركوس (القدس العربي)

وتأتي قصص أخرى لتصب في هذا الايقاع الفنتازي وبنيات الخرافية الشعبية. ومن أهم النصوص التي تعتمد هذا البعد. ولا تقف لا عند مستوى التجميع للحكايات وسردها فحسب، وانما تجعل من فنية متماسكة متناسقة البنية، نذكر من قصة «نعم، تستند كليا الى الحلم الفنتازي الايهامي «طائر الجنة» التي من عمق البطل ويجسد ميله للكذب والنفاق. هكذا تصور القصة البطل وهو يعيش واقعه والخيال.

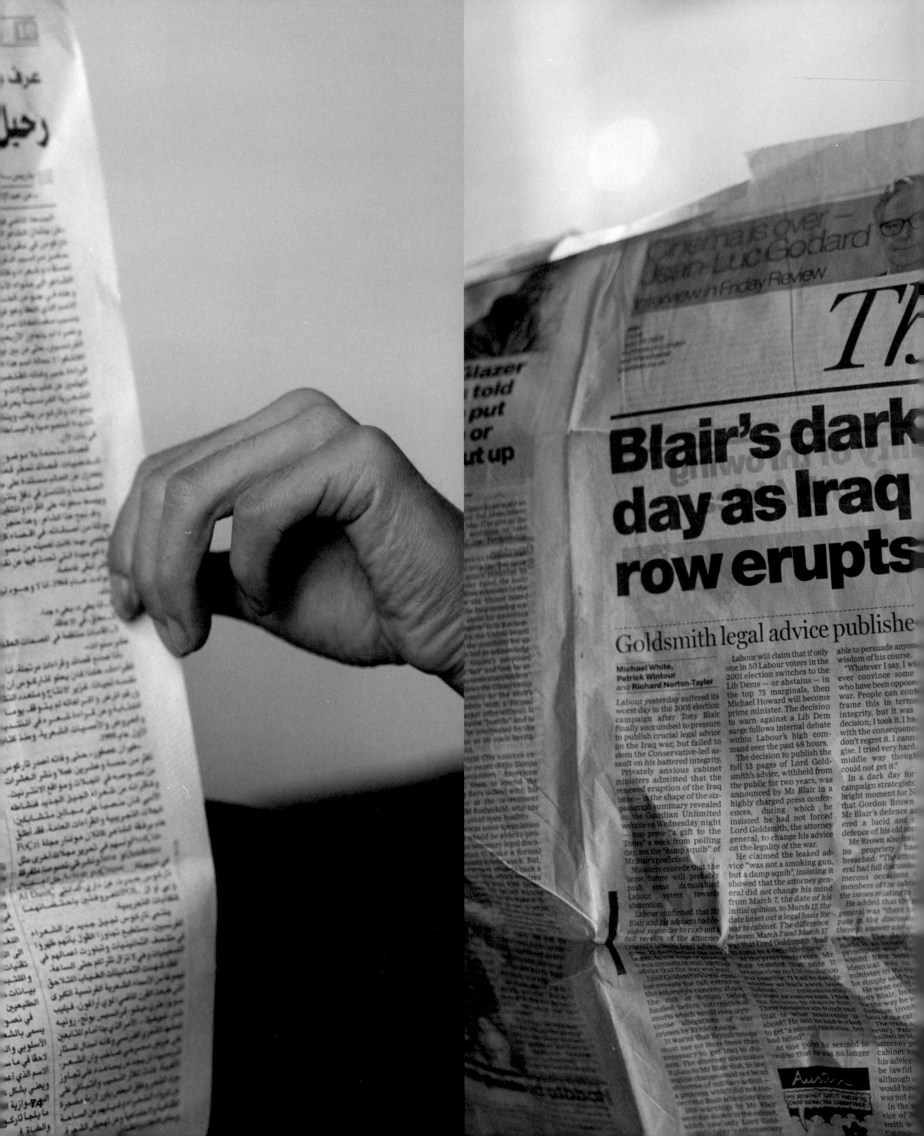

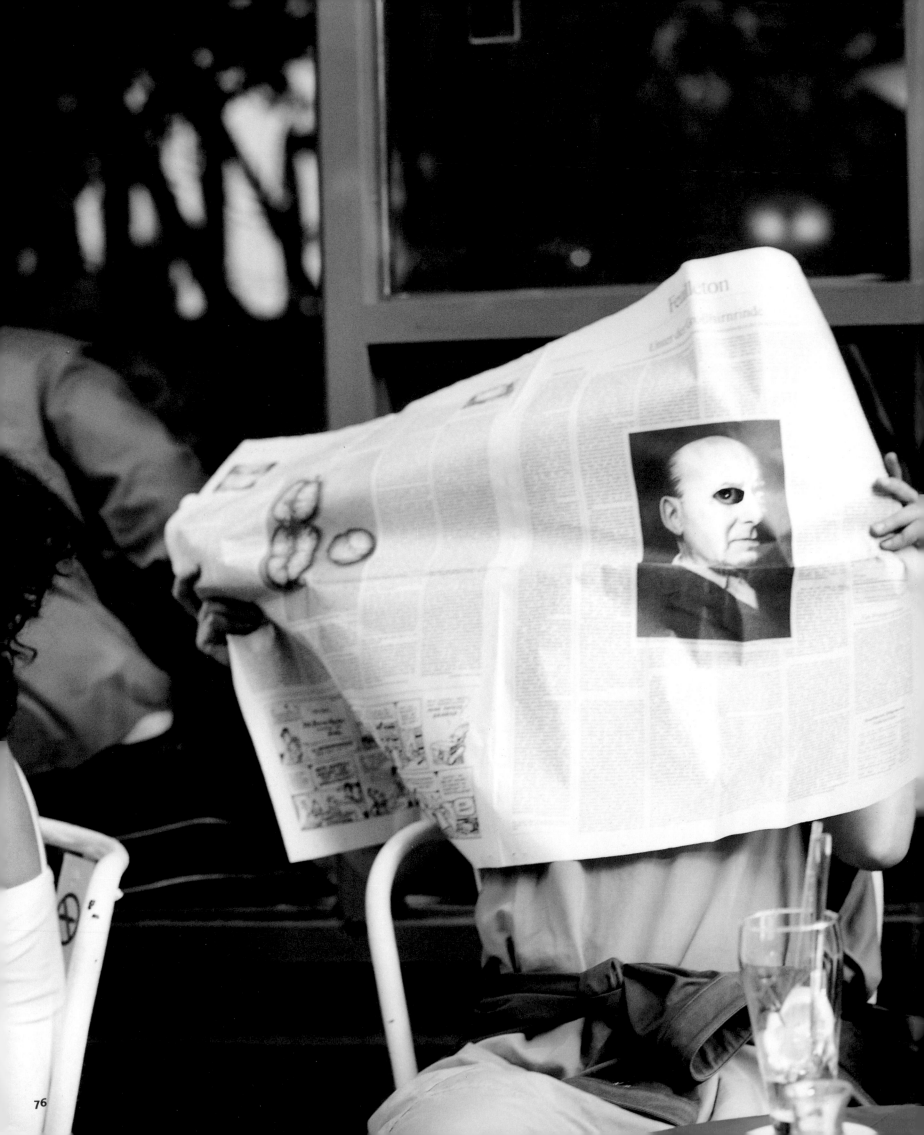

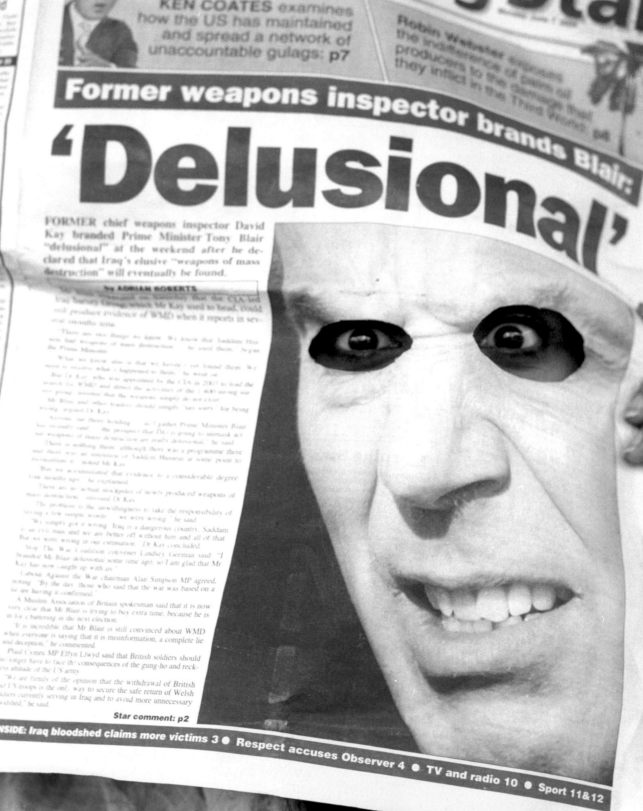

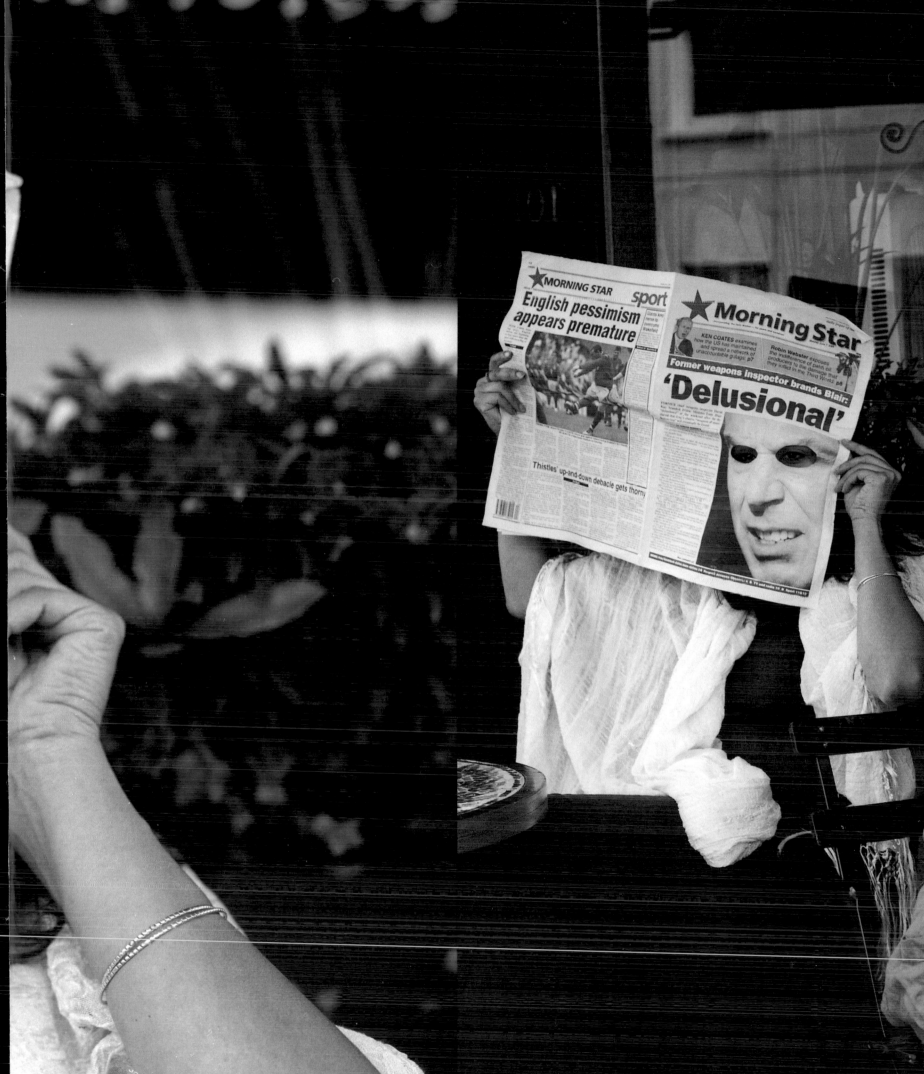

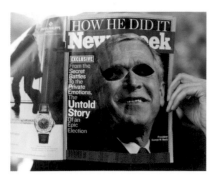

Newsweek, Paris, 2004

The Times, London, 2004

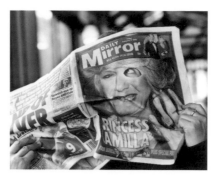

Daily Mirror, New York, 2005

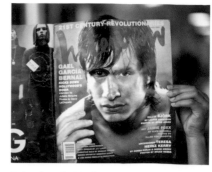

Interview, Rotterdam, 2004

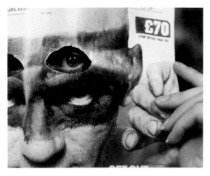

TimeOut London, London, 2005

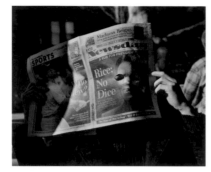

Newsday, New York, 2005

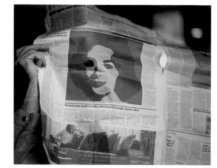

The Guardian, Vilnius, 2005

Metro, London, 2005

The Daily Telegraph, Paris, 2005

Courrier, Barcelona, 2004

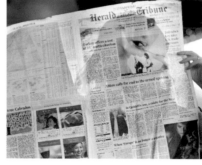

Herald Tribune, Rotterdam, 2004

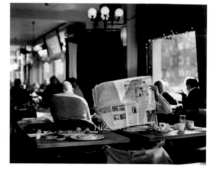

Herald Tribune, Rotterdam, performance, 2004

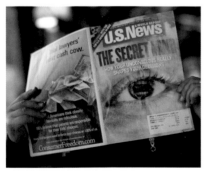

U.S. News, New York, 2005

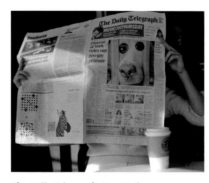

The Daily Telegraph, New York, 2005

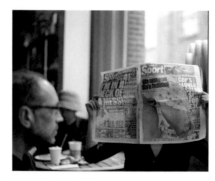

Daily Sport, London, 2005

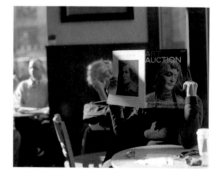

Art + Auction, New York, 2005, performance

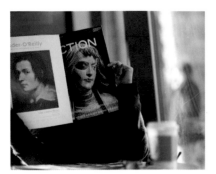

Art + Auction, New York, 2005

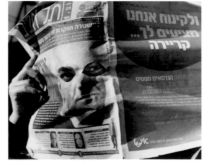

Al Kudz, Berlin, 2005

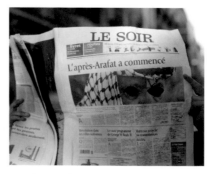

Le Soir, Barcelona, peformance, 2005

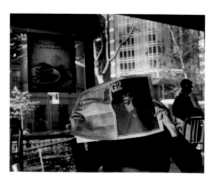

G2, New York, 2005, performance

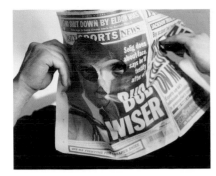

Daily News, Berlin, 2005

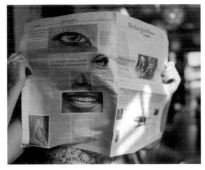

The New York Times, London, 2005

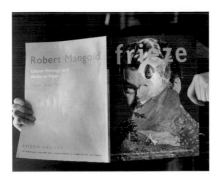

Frieze, Vilnius, 2005

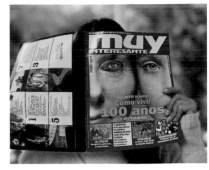

Muy, Barcelona, 2005

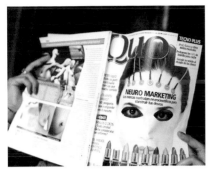

Quo, London, 2005

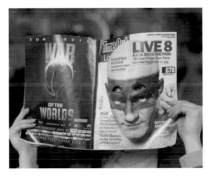

TimeOut London, London, 2005

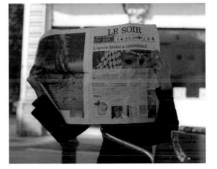

Le Soir, Barcelona, peformance, 2005

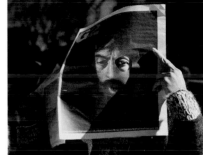

Le Soir, Barcelona, 2005.

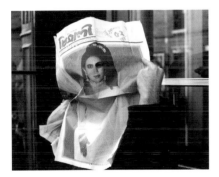

Chitarali, New York, 2005

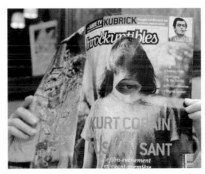

Inrockuptibles, Paris, 2005

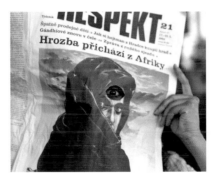

Respekt, London, 2004

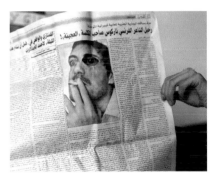

Al-Quda Al-Arabi, London, 2004

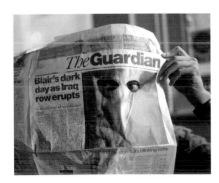

The Guardian, London, 2005

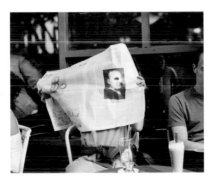

Feuilleton, Berlin, performance, 2004

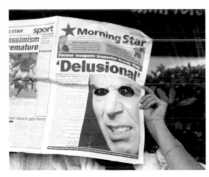

Morning Star, London, 2004

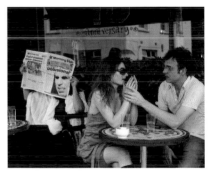

Morning Star, London, performance, 2004

Warren Neidich is currently a research fellow at Goldsmiths College, London. He believes that a role of the artist is to enlarge the notion of what art is and what it can be. Art is a continually expanding universe of possibilities that through its interaction with other discourses generates new languages with which the mind can play and create. Neidich uses photography, cinema, and new media to discover how aesthetic practice, philosophy, architecture, and design interface in abstract ways with new ideas of perceptual becoming, such as neuroplasticity and Neural Darwinism/Neuroconstructivism. Together they reconfigure and revitalize conceptual-based practice, providing new means to produce and distribute information. In the end these coevolving systems form a collective choreography, to produce ways to understand the construction of global subjectivities, what he refers to as *Earthling*. He calls this methodology "Neuroaesthetics", a term he coined in 1995 in a series of lectures he presented at the School of Visual Arts, New York. He founded the *Journal of Neuroaesthetics* and cofounded www.artbrain.org in 1997. Neidich curated the exhibition Conceptual Art as a Neurobiological Praxis at the Thread Waxing Space, New York in 1999. In the past six years he has organized many conferences including "Can Art Investigate the Brain", College Art Association, New York, 1999, "Buildings, Movies and Brains", UCLA Department of Art, 2002, "The Phantom Limb", and "Neuroaesthetics", Goldsmiths College, 2005. His art work has been internationally exhibited in institutions such as the Whitney Museum of American Art, New York, Palais de Tokyo, Paris, Ludwig Museum, Cologne, Los Angeles County Museum of Art, Los Angeles, and the Walker Art Center, Minneapolis. Recent group shows include Astrup Fearnley Museum of Modern Art, Oslo, the Institute of Contemporary Art, London and the Contemporary Art Center, Vilnius. He was the American representative at the Glenfiddich Artistic Residency, Scotland for the summer of 2005. He is the author of *American History Reinvented* (Aperture, 1999), *Camp O.J.* (University of Virginia Press, 2001), and *Blow-Up: Photography, Cinema, and the Brain* (DAP, 2003). A one-person show is planned for the fall of 2005 at Michael Steinberg Fine Art, New York, where he will present his *Earthling* project for the first time.

Hans Ulrich Obrist born May 1968 in Zurich, lives in Paris.
Curator, Musée d'Art Moderne de la Ville de Paris.

Barry Schwabsky is the author of *The Widening Circle: Consequences of Modernism in Contemporary Art* (Cambridge University Press, 1997) and *Opera: Poems 1981-2002* (Meritage Press, 2003) and has contributed to books such as *Jessica Stockholder* (Phaidon Press, 1995), *Gillian Wearing: Mass Observation* (MCA Chicago/Merrell, 2002), *Vitamin P: New Perspectives in Painting* (Phaidon Press, 2002), and *The Undercut Reader: Critical Writings on Artists' Film and Video* (Wallflower Press, 2002). He lives in London.